THE NEW COLORED PENCIL

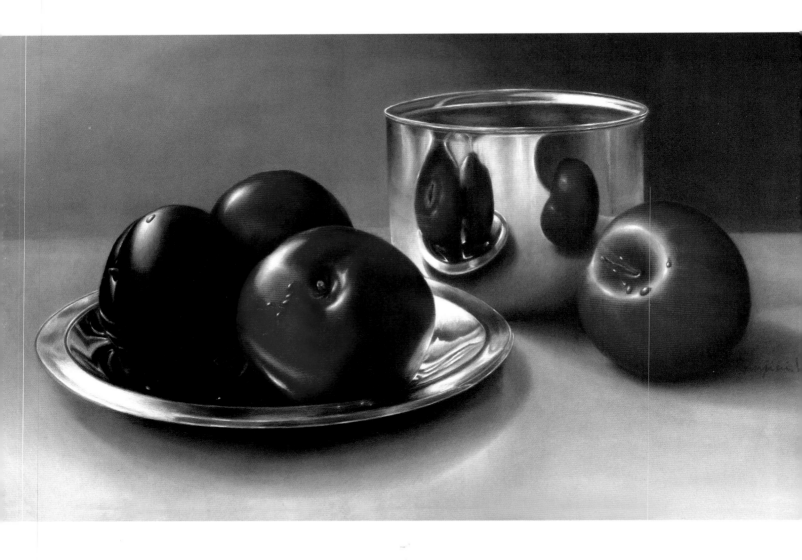

THE NEW
COLORED
PENCIL

Create Luminous Works with Innovative Materials and Techniques

KRISTY ANN KUTCH

WATSON-GUPTILL PUBLICATIONS
Berkeley

This book is dedicated to my dear family:
Ed, Mary, Joe, and Eddie. You are the loves of my life!

Copyright © 2014 by Kristy Ann Kutch

Published in the United States by Watson-Guptill Publications, an imprint of the Crown Publishing Group, a division of Random House LLC, a Penguin Random House Company, New York.
www.crownpublishing.com
www.watsonguptill.com

WATSON-GUPTILL and the WG and Horse designs are registered trademarks of Random House LLC

Library of Congress Cataloging-in-Publication Data
Kutch, Kristy Ann.
 The new colored pencil : create luminous works with innovative materials and techniques / Kristy Ann Kutch. — First [edition].
 pages cm
1. Colored pencil drawing—Technique. I. Title.
 NC892.K885 2014
 741.2'4—dc23
 2013027956

ISBN: 978-0-770-43693-3
eISBN: 978-0-770-43447-2

Printed in China

Design by Chloe Rawlins

Cover art by Kristy Ann Kutch
Back cover art by Ranjini Venkatachari, Kristy Ann Kutch, Jeannette Swisher Buckley, and Jackie Treat

10 9 8 7 6 5 4 3 2 1

First Edition

PAGE 2: *Mutual Admiration*, Ranjini Venkatachari, CPSA, 2008, 34" x 24", water-soluble wax pastel and colored pencil on Pastelbord. Collection of Beth and Terry Gatto-Russeff.

In this piece Ranjini Venkatachari balances the visual weight of the objects by arranging them around the center of the composition, deliberately overlapping to create depth and further emphasize the design effect. Ranjini chose a textured surface, blending water-soluble Neocolor II wax pastels on it, followed by layers of colored pencils; the overall effect is a full, saturated painting with lots of detail.

PAGE 6: *Chambered Nautilus*, Karen Coleman, CPSA, 2005, 10" x 8", colored pencil on Pastelbord. Collection of Merv and Judith Rosen.

This piece by Karen Coleman makes dynamic use of negative space. She captures the play of light on the colorful patterned exterior of the shell and creates contrast with the rich blue background, evoking the deep sea where it makes it home. Fuzzy La Carte pastel paper also allowed a dense and speedy buildup of colors.

ACKNOWLEDGMENTS

I am especially thankful to these people who generously
helped and supported me as I wrote this book:

Richard Berman

Bet Borgeson

Ed Brickler

Dana Brown

Walt, Susie, and Richard Bukva

Tim DePack

Kristen-Lee Derstein

John and Karen Divis

Barbara Faro

Sue Freudenthal

Diana Garrett

Janie Gildow

Michael Ginsburg

Nick Graham

Mike Grecian

Karl Haberer

Nora Hackenberg

Linda Lucas Hardy

Janet Hoeppner

Michael Kalman

Jeannie Lawson

Stefan Löhrer

Susan Marcus

Joyce McBriarty

Joe Miller

Leila Porteous

Andrea Pramuk

Ester Roi

Thomas Richards

Kyle Richardson

Linda Saft

Marc Schotland

Christa Trivisonno

Eric Valentine

Lori Villalonga

Eric Vitus

Bernadette Ward

And most of all, Edward Kutch.

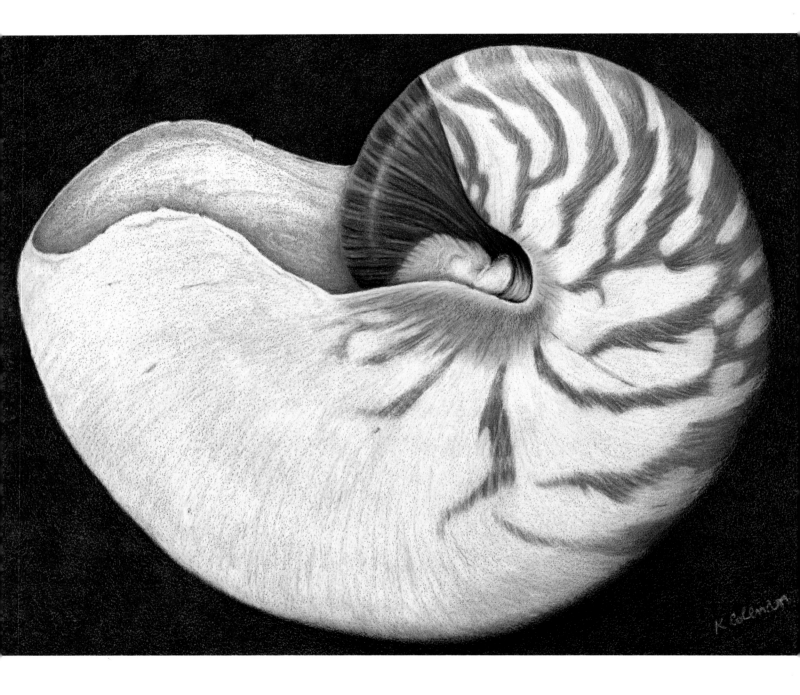

CONTENTS

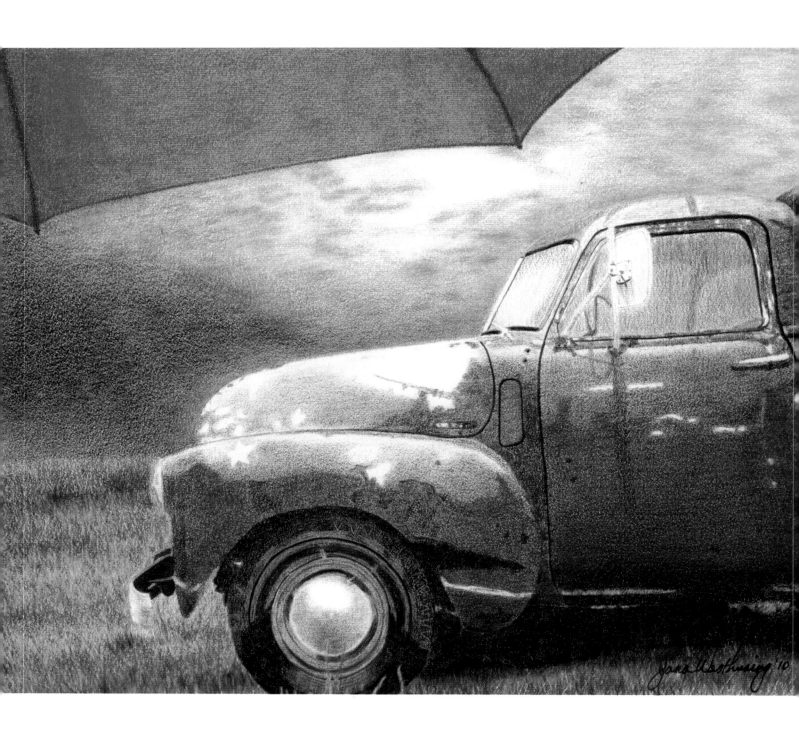

INTRODUCTION

From the first time I picked up a colored pencil in my local art league class, I have been intrigued by the medium. More than two decades have passed since that course, and I have embraced the growth of colored pencil as a fine art medium with great enthusiasm. Since my first book, *Drawing and Painting with Colored Pencil,* was published by Watson-Guptill in 2005, there have been many product and technique developments. With a spirit of fun and adventure, I have incorporated new pencils, wax pastels, tools, and approaches into my own art. Whether I drew, brushed, grated, spattered, or even blew pigment through a screen, it has been an enjoyable and satisfying experience. In recent years, many new varieties and types of colored pencils have emerged, each with their own merits and characteristics—and sometimes inspiring new techniques. The varieties of pencils and the palette of colors in which they're available have grown beyond wax- or oil-based "permanent"

Rusty Truck in Rain Forest, Jana Westhusing, 2010, 10" x 8", colored pencil on Stonehenge paper.

Jana Westhusing chose Prismacolor pencils and Stonehenge paper because she likes these materials for their ability to enhance fine details. The combination allowed for the photo-like quality of this art.

traditional pencils. Water-soluble drawing products now include new types of watercolor pencils, including ink-like pencils and even tinted aquarelle graphite pencils. Pigments are rich and dense, and more emphasis has been placed on lightfastness for the permanence of one's art.

The emergence of water-soluble wax pastels—which may *look* like crayons but which offer much more in terms of quality, speed, and versatility—has been perhaps the most surprising development in the world of color drawing and painting. Aquarelle wax pastels swiftly cover large areas with rich pigment that dissolves instantly with the sweep of a damp brush. The wax pastel can also be sharpened to a point, or the pigment can be stroked from the tip with a wet brush. This type of aquarelle wax pastel can yield a highly pigmented liquefied wash which can then be applied with a brush.

New and diverse drawing and painting surfaces that are colored pencil–compatible have emerged, too. Longtime favorite lines of paper have expanded to include more colors. New brands of papers have appeared with a variety of textures, to appeal to artists' wide-ranging tastes. Versatile illustration board ideally designed and textured for wet media as well as dry is now on the market. Translucent film–like vellum, acid-free and of high quality, offers speedy, rich laydown of colors. From fine-toothed silky paper to sandy-textured boards, dazzling pure white or toned to a range of colors, such supports offer an aspiring array of textures, hues, and unique traits—the potential unfolds with great possibilities.

Colored pencil is ever-blossoming as a fine art medium, bringing with it new materials and surfaces, even an expanded concept of what "drawing a painting in color" means. This book presents many possibilities and techniques for widening those colored pencil boundaries.

Artists whose work I have admired over the years, whether they were long-recognized figures in colored pencil circles or emerging artists I met through my workshop travels, have been generous in sharing their art, describing their tools and techniques, even revealing their sources of inspiration. You will linger and marvel over their art as I, too, have done. I am most grateful for their participation and the enhancement that their art has lent to *The New Colored Pencil*. My deepest gratitude goes to these very special guest artists, whose contributions so enhance these pages: Debbie Bowen, Jeannette Buckley, Karen Coleman, Barbara Grant, Mary Hobbs, Laura Miller, Jackie Treat, Ranjini Venkatachari, and Jana Westhusing.

I hope that learning about colored drawing materials and seeing the work of colored pencil artists will inspire you to consider such techniques and materials and to continue to grow creatively.

Mushrooms, Karen Coleman, CPSA, 2009, 7" x 5", colored pencil on Pastelbord.

Karen Coleman used a range of closely related hues—from a very pale ivory to deep sepia—and close-cropped composition to create this quiet, yet striking, piece.

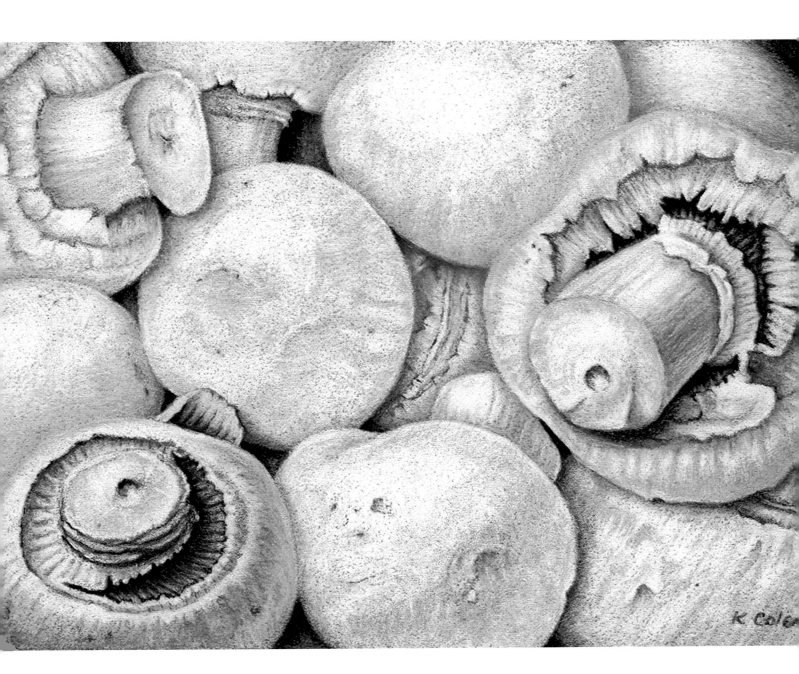
K. Coles

WAX-BASED TRADITIONAL COLORED PENCILS

1 GETTING STARTED WITH WAXY COLORED PENCILS

Some brands, such as Sanford Prismacolors, offer more than one hundred colors and an extended range of grays: French grays, warms grays, and cool grays. Such a broad range of grays appeals to the artist who prefers the bold or quaint look of black-and-white images, as well as photographers who specialize in reproducing and restoring old photographs.

WHEN AN ARTIST USES THE TERM *COLORED PENCIL*, generally the wax-based permanent, traditional pencil comes to mind. Such non-aquarelle pencils are the most prevalent type and can be found in a variety of styles, thicknesses, and hardnesses. The colored pencil—whatever its form—is nontoxic, portable, and affordable. It is also beautifully suited to color delivery, control, and precision.

Quality art begins with quality art materials. With such a large variety of pencil brands, it can be difficult to decide what products to buy. No matter what your budget, you should always aim for quality above quantity as you build a collection of colored pencils. A small basic set of quality colored pencils can be gradually expanded by purchasing additional hues from open stock of individual colors. Look for a range of suitable colors based on preferences and subject matter.

PREVIOUS PAGE: *Bierstadt Trail*, Jeannette Swisher Buckley, CPSA, 2001, 36" x 16", colored pencil on vellum-finish Bristol board.

Bierstadt Trail is in the Rocky Mountain National Park—a great subject since it is a favorite hiking spot for Jeannette Swisher Buckley and since she loves portraying trees and rocks. Jeannette used Prismacolor pencils on Strathmore Bristol paper, vellum finish, one of her favorite papers.

NEXT PAGE: *Kathakali, Portrait of an Indian Dancer*; Ranjini Venkatachari, CPSA, 2007, 14^1/$_2$" x 24", colored pencil, pastel, and gold leaf pen on Pastelbord.

Ranjini Venkatachari created this work as a tribute to Kathakali, meaning "story play," an art form that originated in south India more than five hundred years ago. Combining literature, music, painting, acting, and dance to portray stories from the Hindu epics, the dancer uses concentration, skill, and stamina to present a spectacular performance. Ranjini applied an initial layer of pastels on Pastelbord, lightly sprayed it with a fixative, and followed with colored pencils on top of the pastels to add more details. She then created raised areas with Art Spectrum Colourfix Primer, allowing it to dry overnight; her final step was to apply gold leaf pen to these raised areas to add a vivid effect.

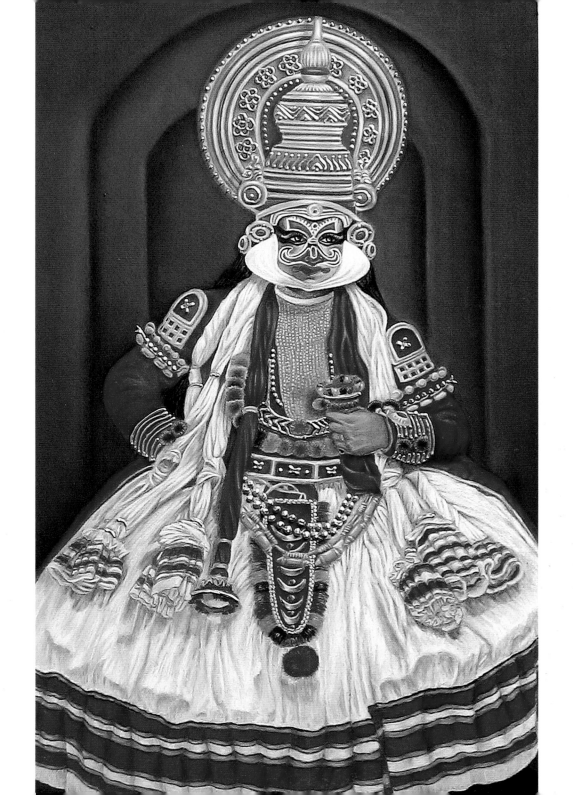

This chapter presents a survey of the top traditional waxy pencils on the market today, based on their unique makeup, functions, and value. All of the brands I mention are considered artist-grade pencils and almost all of them offer open-stock refills of individual colors.

MAKEUP AND CONSTRUCTION

Professional-grade colored pencils have a higher percentage of pigment and better quality construction than the student-grade colored pencils commonly found in variety and school or office supply stores.

Core Composition

Colored pencil "leads" are composed of pigment, waxes, and other ingredients such as extremely minute particles of clay, titanium dioxide, and—for smoothness—talcum. (Although the core is often called the lead, it is not the same composition as a lead pencil and does not contain graphite.) Gum binders form a thin coating around these minute particles, bonding them together. Molten waxes then fill the spaces between these particles; waxes enable the actual drawing process. Different brands use various recipes and proportions of these ingredients, as well as multiple synthetic waxes (so-called "dry" or "wet," with the latter liquefied wax having oily drawing, or laydown, characteristics). The waxes are essential for making the pencil strokes actually adhere to the paper. Applying colored pencil is very much a sensory, tactile experience.

Buttery, "Wet" Pencils

Faber-Castell includes vegetable oil (soybean oil) in its Polychromos pencils, lending a characteristic smoothness and glide. The line offers 120 highly pigmented hues and, despite their characteristic softness, they are very concentrated and durable. Faber-Castell's S.V. bonding system of internal adhesive keeps the cores in their premium-quality wooden jackets. S.V. is a Faber-Castell trade term for "sekuralverfahren," meaning "secure bonding" of the pencil core to the internal part of the wooden casing. Polychromos can

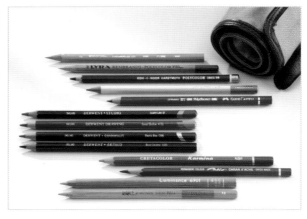

Different brands of traditional, non-water-soluble pencils have different traits, ranging from crisp and fine to creamy and waxy. Thirteen prominent varieties of artist-grade pencils are, from top to bottom: Sanford Prismacolor, Lyra Rembrandt Polycolor, Koh-I-Noor Polycolor, Irojiten, Faber-Castell Polychromos, Derwent Studio, Derwent Drawing, Derwent Coloursoft, Derwent Artist, Cretacolor Karmina, Caran d'Ache Pablo, Caran d'Ache Luminance, Bruynzeel Design.

be easily used on their sides or sharpened to a fine point for excellent precision, too. Budget-friendly Koh-I-Noor Polycolors, in 36 shades, also have vegetable oil blended into the wax.

Caran d'Ache Pablo and Luminance (see *Lightfast Superstar*, page 20) and Lyra Polycolors (see *Uniquely Constructed Pencils*, page 19), do not contain vegetable oil, but due to the types of waxes they contain, they still lend a buttery glide sensation in the laydown process. Caran d'Ache's 120 Pablo pencils are dipped in a wax bath and cured; they create a resist effect when watermedia is layered over them. The Pablo feels like

a soft 6B graphite pencil and fills in the tooth of the paper with beautiful saturation. This is a bonus for the artist who wants a smooth, unflecked effect. The Pablo pencil also lends itself well to translucent color layering, with every hue appearing as a subtle veil in the color harmony.

Other creamy, "wet" pencils include the 72 Derwent Coloursoft shades and the 150 Sanford Prismacolor pencils. The 24 shades of Derwent Drawing Pencils, touted as "the fur and feather pencils," are ideal for subjects from nature and landscapes; they are thick and soft, almost pastel-like, in texture.

Karen's Tulip, Kristy Ann Kutch, CPSA, 2013, 11⁷/₈" x 9¹/₂", colored pencil on Rising 4-ply museum board.

This floral art combines two familiar materials, museum board and Faber-Castell Polychromos pencils. The easy laydown of the Polychromos pencils, which contain soybean oil, combines well with the velvety, almost cushioned feeling of Rising Museum Board. Since the pencils are highly pigmented and the board accepts color so readily, they were a natural blend.

Crisp, "Dry" Pencils

Derwent Studio Pencils (in 72 shades) and Artist Pencils (in 120 shades), on the other hand, lend a drier, sharper sensation, something which appeals to artists who like to keep fine lines and precision in their work. Sanford's 36 shades of Verithin pencils, while not heavily pigmented, are excellent tools for creating fine lines. Verithins, which are needle-like and quite hard, help tremendously in bringing an image into focus, making edges look crisp and precise with just a few strokes.

Whichever brand or level of softness appeals to the artist, the proof is ultimately in the pigment.

Densely Pigmented Pencils

Pigment is the essential component of the colored pencil. Without adequate pigmentation, the colors are lifeless, bland, and lackluster—producing faint, scratchy drawings. Thus, it is vital to choose colored pencils which produce rich hues.

The 90 premium Irojiten colored pencils are heavily pigmented. (*Irojiten* is Japanese for "color dictionary.") Packaged in neatly organized sets of colors, they include light pastel colors, deep tones, and a large selection of vivid and realistic muted colors found in nature. The extensive palette of Irojiten greens is especially notable. Offering some dramatic color accents, this collection includes fluorescent colors.

Caran d'Ache Luminance pencils offer many earthy and landscape hues, as well as yellows, oranges, reds, blues, and violets. They are formulated using seventy pigments—not thirteen to fifteen, like many other brands—which means that the artist can effortlessly deliver more color per stroke, without applying heavy pressure and with fewer layers.

THE CORE ISSUE

When shopping for open-stock pencils, examine the cross section of each colored pencil, and only select those with centered cores. Off-center pencil cores occur when quality-control problems arise; sometimes uneven slabs of wood are bonded together to form the casing. Such flawed pencils do not sharpen properly, even in a handheld sharpener, and can lose their colored cores. Caran d'Ache of Switzerland and Faber-Castell of Germany apply continuous adhesive within their pencils, thus eliminating the problem of losing an entire chunk of pencil.

AVOID PENCILS WITH OFF-CENTER CORES. SUCH PENCILS ARE DIFFICULT TO SHARPEN AND HAVE LOPSIDED, OFTEN UNSTEADY POINTS.

(For more on the Luminance line, see *Lightfast Superstar*, page 20.)

Uniquely Constructed Pencils

Colored pencils are available in unusual casings or even woodless form. Prismacolor Art Stix, offered in 48 colors, are essentially the large cores of Prismacolor Premier pencils, produced as chunky rectangular sticks with no wood casing. They are well-suited to creating

Pears and Hazelnuts, Kristy Ann Kutch, CPSA, 2013, 11⁷/₈" x 9¹/₂", colored pencil on vellum-finish Bristol board paper.

Buttery Lyra Polycolors contain a liquefied "wet" wax, with no soybean oil. While I appreciate their range of useful colors—plenty of greens, yellows, reds, and blues—it is the gliding *feel* of the pencil that is so appealing. Polycolors also have the ability to, if desired, fill in even the tiniest flecks of tooth in the art surface.

large swaths of color and gestural drawings. Some artists even grate the Art Stix and spread the powdered pigment over the paper for soft-effect coverage.

The 16 Lyra Colorstripe pencils, on the other hand, feature a triangular cross-section and the 6.25 mm "leads" are visible along one side of the pencil. This wide strip of colored core can be used for covering large areas. The point can be sharpened and also used for more precise strokes. Colorstripe pencils are very similar in composition to Lyra Polycolor pencils and are also of the same high quality. Lyra's 72 shades of Polycolors have long been noted for their silky laydown quality, the pigment sinking easily into the texture of the paper, and their wide range of vivid colors, including flesh tones.

From the Czech Republic, Koh-I-Noor has recently introduced Tri-Tone Colored Pencils, a set of 23 multitonal pencils, plus a blender pencil, which

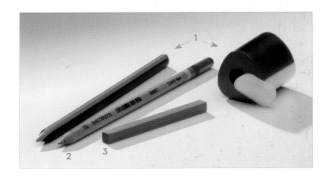

Unique forms of the colored pencil offer speed and convenience: 1) the Lyra wide-core Colorstripe pencil (and its sharpener), 2) Koh-I-Noor Tri-Tone pencil with its three related colors braided into one core, and 3) the large Sanford Prismacolor Art Stix.

are made of the same oil- and wax-based core material as the company's Polycolor pencils. The intriguing difference with Tri-Tones is that each 3.8 mm pencil "lead" has a braided core containing three analogous hues or a color with three different values. Tri-Tones deliver random, yet related colors, a useful application for landscape art, rendering dimensional trees, grasses, and fields.

Specially Formulated Pencils

Artists ask a lot from their pencils—whether it's consistent laydown, resistance to the elements over time, or the ability to make faint lines that won't be detected in the final work. Manufacturers make products to accommodate each of these needs.

Lightfast Superstar

Lightfastness, the permanence of a medium when exposed to light, is an issue of vital importance to all artists. This is especially true of practitioners whose art is commissioned and anyone who wants the guarantee of art that endures.

An elite newcomer to the colored pencil scene is the Caran d'Ache Lightfast collection from Switzerland. Luminance pencils contain levels of pigment and wax that are much higher than the average artist-grade pencil and have been subjected to rigorous laboratory and Arizona and Florida sunlight testing (more than four hundred pigment combinations were tested) to measure permanence and resistance to fading. They are also painstakingly constructed so that wax bloom never occurs. Cores are placed in stringently

Fluttery Tulips, Kristy Ann Kutch, CPSA, 2013, 9¹/₂" x 11⁷/₈", colored pencil on Colourfix Suede paper.

Caran d'Ache Luminance pencils offer top-of-the-line lightfastness and therefore insurance for the permanence of my work. If I invest many hours in a colored pencil painting, I want it to endure! Luminance pencils also contain maximum pigment and highest-quality waxes, so the rich colors adhere readily, greatly reducing my layering time.

measured California straight-grain cedar cases, with no warped or bent pencils and no core loss.

Wax Bloom Warriors

Colored pencil artists are also particularly eager to avoid wax bloom, a hazy surface film which can develop when some types of colored pencils have been applied with repeated layers of heavy pressure.

Design colored pencils, from the Dutch-based pencil company Bruynzeel, have returned to wider international distribution, including the United States. Featuring 48 colors, Design pencils are manufactured under stringent standards that prevent wax bloom. Each pencil has a grooved core with two types of glue, one applied to the core and one on the wooden casing, to double-bond it within the casing. Bruynzeel encases their pencils with light cedar, which is preferable to red cedar for smooth sharpening. Lending themselves well to layering, Design pencils yield the lovely translucency of subtle veils of color.

Faber-Castell, Irojiten, Koh-I-Noor, and Lyra pencils all tout their resistance to wax bloom, due to the chemistry of their pencil composition and the quality of the art waxes they use.

This is an enlarged image of wax bloom.

Non-Photo and Sketch-Friendly Tools

Three inexpensive types of colored pencils, one from Caran d'Ache and two from Sanford, are valuable accessories for creating line drawings and adding finishing touches. Caran d'Ache offers a soft, non-photo blue Sketcher pencil, which erases easily with its own white vinyl eraser and is not visible to most cameras (although it does appear on many types of scanners). The blue is dark enough to be visible to the artist, but not so dark as to create lines that are too heavy. The Sketcher promises to be a valuable and forgiving tool in creating basic line drawings.

The 24 Sanford Col-Erase Pencils are not dense in pigment like the usual artist-grade colored pencils. They are ideal, however for creating preliminary sketches and line drawings. The Col-Erase pencil—lavender

is a versatile favorite—is well-suited to line drawings depicting even delicate hues, such as yellow objects, which could later show distracting lines if drawn with dark graphite strokes. Col-Erase pencils are forgiving and can be easily erased (preferably with a white vinyl eraser, rather than the pink eraser on the pencil's tip).

Sanford Verithin pencils are needle-sharp and not highly pigmented. With their fine lines, they are wonderful tools for drawing whiskers, eyelashes, stamens and pistils in flowers, and other delicate details. They are also ideal for lending crisp edges and a sharply focused look to the finished art.

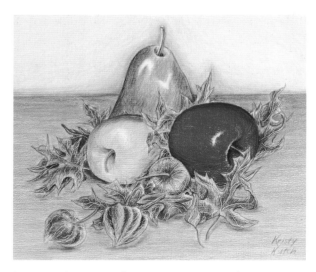

Lanterns, Leaves, and Fruit, Kristy Ann Kutch, CPSA, 2013, 11⁷/₈" x 9¹/₂", colored pencil on vellum-finish Bristol board paper.

Autumn is a wonderful time of the year to find appealing fruits, vegetables, and other plants to draw and paint. I found these delicate Chinese lanterns at a local country gift shop located on my late mother's homestead, in my grandfather's nineteenth-century barn. Understandably, the delicately incised lanterns have special significance and I enjoy using them for autumn inspiration.

COLORED PENCIL STANDARDS FOR LIGHTFASTNESS

With vigorous lobbying by the Colored Pencil Society of America (CPSA) for fuller information has come the establishment of the D-6901 lightfastness standard. Stringent procedures expose colored pencils to strenuous testing, yielding information about their permanence. Because of this insistence on lightfast pigments, colored pencil is gaining acceptance as a fine art medium.

CPSA publishes a lightfastness workbook, available to its members. It is researched and updated, with ratings for colored pencils, watercolor pencils, and wax pastels. I regularly consult this workbook when planning a painting.

TRADITIONAL WAXY PENCIL COLLECTIONS AND TRAITS

PRODUCT NAME	NUMBER OF SHADES	PRICE LEVEL	KEY CHARACTERISTICS
Bruynzeel Design	48	Budget-friendly	Wax-based, excellent pencil construction and laydown qualities, no wax bloom
Caran d'Ache Luminance	76	High-end	Outstanding lightfastness, very concentrated color and coverage, great pigmentation combined with quality art waxes
Caran d'Ache Pablo	120	High-end	Wax-based, combines a soft feel (equivalent to that of a 6B pencil) with excellent coverage of the tooth of the paper
Cretacolor Karmina	36	Moderate	Wax-based, crisp-feeling, very lightfast pencils, not widely distributed nor available in open stock
Derwent Artist	120	Moderate	Great color selection, crisp laydown sensation; pencils are slightly oversized for many sharpeners
Derwent Coloursoft	72	Budget-friendly	Very soft and creamy wax-based pencils in a brilliant selection of colors
Derwent Drawing	24	High-end	Soft wax-based pencils in muted colors of nature
Derwent Studio	72	Moderate	Long-established line of wax-based pencils with sharp, crisp characteristics
Faber-Castell Polychromos	120	Moderate	Excellent pigmentation and construction, smooth and buttery laydown; formula includes soybean oil
Irojiten	90	High-end	Outstanding range of highly pigmented hues, no wax bloom, arranged in book-like volumes of color families, including ideal landscape colors
Koh-I-Noor Polycolor	36	Budget-friendly	Oil-based pencils that feature a creamy laydown quality
Lyra Rembrandt Polycolor	72	Moderate	Beautiful palette, no wax bloom, and a smooth, silky gliding sensation of color laydown
Sanford Prismacolor	150	Moderate	Huge range of colors, waxy composition, popular, widely available, often on sale; tend to have some quality control flaws

2 COMPATIBLE SURFACES FOR WAXY COLORED PENCILS

THE BEST PENCILS IN THE WORLD CANNOT DO justice to one's art unless they are paired with a quality, acid-free ground or surface. Selecting an appropriate paper or board is largely a matter of preference, style, and the need for tooth. In this case, "tooth" refers to the texture of the surface—whether it is a velvety, rather smooth paper, or a sanded, gritty board. Consider, too, the subject matter of the art. Using a sanded, toothy paper might be appropriate for a landscape of a rugged canyon, ravine, or mountain. On the other hand, a smooth, less textured surface may be better suited to a portrait of an infant with delicate skin or a still-life which includes highly reflective crystal.

There is an amazing array of art surfaces—some tried and true, some quite new—which are ideal grounds for colored pencil art. More art surfaces are being recognized as colored pencil compatible, too. Surfaces that used to be in the realm of pastelists or watercolor artists have proven to be beautifully suited to colored pencil artists. Papers and multiple medium boards from around the world offer a wider range of textures, colors, traits, and effects.

The more you learn about how different colored pencils and surfaces interact and work together, the more your range of possibilities will expand.

Eagle Eye, Jackie Treat, 2012, 12" x 16", colored pencil on Colourfix Suede paper.

Jackie Treat photographed this eagle at the Eugene, Oregon, Raptor Rescue Center; the Oregon CPSA District Chapter held their monthly meeting at the center so artists could sketch and photograph the birds. She chose Tasman blue Colourfix Suede paper because she wanted a soft, misty background; she also knew that the red orange of the eagle's feathers would enhance the vibrant play of complementary colors.

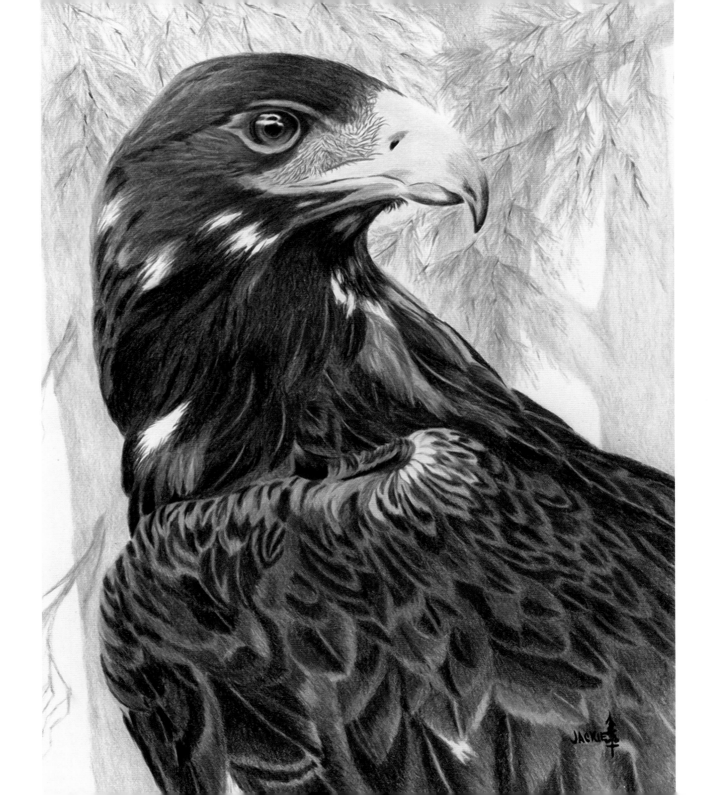

TRIED AND TRUE

Two longtime favorites of colored pencil artists are Bristol board paper and Stonehenge paper. Bristol board, named after the city of Bristol, England, where earliest versions were crafted, is rather stiff and sturdy. It is available in plate finish and vellum (also called "regular" or "kid") finish, and the paper company sometimes notes the number of plies, or thin layers, in each sheet. Plate-finish Bristol board is smooth and, when held up to the light, appears slick and shiny, much like a porcelain plate. Plate-finish board—ideal for pen and ink art—accommodates several pencil layers and allows fine, delicate precision. Vellum-finish Bristol board is slightly toothier and accepts more layers than the plate-finish version.

Stonehenge paper, once mainly considered a silkscreen and printmaking paper, has also been recognized as an important and versatile surface for the colored pencil medium. This paper is 100 percent cotton, acid-free, buffered with calcium carbonate (for environmental protection), and very affordable. Colored versions offer the option of choosing a toned surface for drawing. Although the tooth is subtle, it allows multiple layers, incised lines, delicate detail without feathering (i.e. diffusing a line intended to be fine and crisp), and is forgiving with lifting and erasing.

Rising or Strathmore museum boards are also excellent surfaces for colored pencil. Although it is marketed as an archival, conservation, thick-paper board for framing, museum board offers a wonderful ground for colored pencil. Being 100 percent cotton,

WHITE SURFACES FOR COLORED PENCIL

PRODUCT NAME	KEY CHARACTERISTICS
Bristol board plate-finish paper	Very smooth surface, allows fine detail, limited layering
Bristol board vellum-finish paper	Subtle tooth permits multiple layers; great student paper available in pads
museum board	Sold as framing backing board, lightly textured, ideal as 2-ply or 4-ply drawing surface
Revere paper, felt	Most textured of Revere papers, has an almost cloth-like feel
Revere paper, silk	Lovely Italian paper, fine tooth, delicate with erasures
Revere paper, suede	Same as Revere silk, but more textured
Stonehenge paper	Available in sheets or pads, subtle color variety; "workhorse" paper which accepts erasures, great layering
Terraskin paper	Dense, nonwoven paper made from limestone powder; accepts line impressions and has very fine tooth, unique texture

lightly textured, pure, and suitable for fine-art preservation, museum board is ideal for drawing, too. Four-ply museum board is sturdy and accepts colored pencil with a speedier saturation than many traditional papers. The only drawback is that the board is only available in 32- by 40-inch sheets and may be too large. Look for it among framing supplies, not drawing papers, and inquire about having it cut to size. It is well worth the additional effort to experience such a luscious art board.

Tanner, Jeannette Swisher Buckley, CPSA, 2003, 19" x 24", colored pencil on museum board.

Jeannette Buckley worked from a picture she took on the steps of an old family farmhouse in Coonbottom, Florida, where three generations of family had gathered for Thanksgiving. She uses museum board for portraits, since she likes its durability and appreciates a surface that takes repeated lifting with an electric eraser. The entire scene was done with Prismacolor pencils.

Stonehenge paper enjoys a large following among colored pencil artists who value this paper's texture and its ability to accept multiple layers of color. Assorted shades are conveniently available in Stonehenge pads, which offer a variety of tinted surfaces. Shown here (left to right) are kraft, warm white, natural, cream, fawn, and pearl gray.

NEW ON THE SCENE

A notable new contribution to the world of colored pencil surfaces is Revere paper. Offered in silk (the smoothest), suede (intermediate tooth), and felt (the most textured) finishes and a variety of weights, Revere is 100 percent cotton and comes from an Italian paper mill dating back to 1404. It is also acid-free and has a lovely velvety texture, which accepts multiple colored pencil layers readily. Revere paper lends itself well to impressed lines for precision and textural details.

One unique new substrate, Terraskin, is a nonfiber material. Terraskin is not cotton but is made from calcium carbonate powder, also known as finely ground limestone. Combining calcium carbonate with a small quantity of polyethylene, a nontoxic resin binder, Terraskin is nonacidic and archival. It is concentrated and heavy, tear-resistant and strong, yet it can be cut with household scissors. With a dense, non-toothy feel to it, Terraskin accepts colored pencil very smoothly, and soft, multiple layers appear delicately textured. This surface also accepts line impressions very well, but do not work on it while wearing a wristwatch or bracelet, which might accidentally impress into the paper. When working on a pad of Terraskin, the underside of the sheet should be cushioned with newspaper or a pad of paper: line impressions can even affect the next sheet on the pad. Terraskin is forgiving and colors lift cleanly with a Vanish eraser or white vinyl eraser.

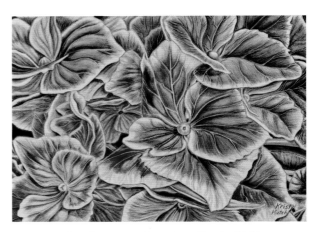

Variegated Hydrangeas, Kristy Ann Kutch, CPSA, 2012, 15" x 12" colored pencil on Terraskin paper.

To create this up-close and personal view of a unique hydrangea, I used a sheet of the new non-fiber Terraskin paper, made from limestone powder. I thought it would be a great surface for the range of transitioning blues, greens, and violets found in this amazing bloom. The Caran d'Ache Pablo pencils stroked easily, almost fluidly, and the gradations of colors were easy to render on the smooth Terraskin.

There is an excellent variety of papers and textures—from smooth to toothy—available for colored pencil art. From left: Terraskin, museum board, Bristol board vellum surface, Revere silk, Revere suede, and Revere felt.

PASTEL SURFACES FOR COLORED PENCILS

Pastel papers and boards are not just for pastelists. Colored pencil artists have discovered the beauty, speed, and novelty of working on colored pastel papers and boards. Such toned surfaces lend an underlying color unity and the hues work up quickly.

Pastel Papers and Boards

There are a number of high quality pastel papers, like Canson Mi-Teintes, Fabriano Tiziano, Sennelier La Carte, and Strathmore Artagain. Canson Mi-Teintes has a light tooth on one side and is pebbly on the reverse. Strathmore's papers tend to be less textured and smoother; Strathmore Artagain has an interesting blend that resembles tweed.

Fabriano Tiziano is also a lighter-weight pastel paper, and some of the colors have a discernible woven look, much like linen. Sennelier La Carte, on a card backing, has a furry tooth which contains dehydrated potato powder; it takes pigment quickly but the tooth is easily damaged by even a droplet of water, so keep your hands dry when working with it. (It is not adversely affected by fixative spray, however.)

Canson offers a veritable rainbow of Mi-Teintes pastel papers, but the company also produces a wide array of rigid boards for drawing. Textures vary from quite smooth, for very fine line work, to textured, for toothier effects. Canson boards include Bristol, drawing, illustration, and even Mi-Teintes paper mounted to a hefty sulfite white board. Mi-Teintes board is available in white,

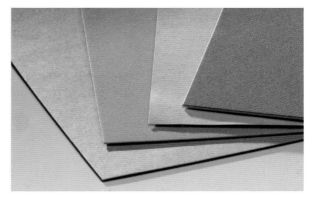

Toned surfaces can lend speed and elegance when creating a colored pencil painting. Shown here are (left to right) Strathmore Artagain, Sennelier La Carte, Fabriano Tiziano, Canson Mi-Teintes.

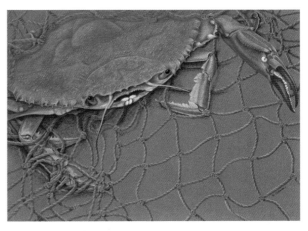

Caught! Callinectes Sapidus, Atlantic Blue Crab, Karen Coleman, CPSA, 2012, 15½" x 11½", colored pencil on La Carte pastel paper.

Karen Coleman selected suede-like Sennelier La Carte paper and Prismacolor pencils, since the pencils work beautifully on this paper, building up very quickly with intense color. Note the wide variety of wonderful textures, from the crab's shell to the braided netting.

ivory, cream, grays, black, tobacco, and burgundy. On these colored surfaces, the art develops quickly, and the composition has an underlying tonal harmony.

PASTEL PAPERS FOR COLORED PENCIL

PRODUCT NAME	KEY CHARACTERISTICS
Canson Mi-Teintes	Very large distribution and color selection; pebbly on one side, smoother on the other
Fabriano Tiziano	Lightweight paper in wide color range, features linen-weave tooth
Sennelier La Carte	Fuzzy paper with speedy saturation; tooth is damaged by water
Strathmore Artagain	Wide distribution; medium-weight paper featuring speckled, tweed-like surface

Sanded Pastel Surfaces

Sanded pastel surfaces offer textures ranging from fuzzy to downright gritty and are generally toothier and more abrasive to colored pencils. While a sanded tooth may wear down the pencil point more quickly, the reward is the speedy saturation of color. The tooth of the paper or board grabs the pigment, and the color clings with rich intensity. This can be especially useful for landscapes, for example, which take shape quickly on such surfaces. Many sanded pastel grounds are also compatible with water-soluble drawing products like watercolor pencils and wax pastels. This makes such surfaces ideal for combining dry and wet drawing and painting.

Lightly Sanded Surfaces

Color clings well to lightly sanded surfaces, yielding rich saturation with less aggressive wear on the pencil points. Art Spectrum Colourfix Suede, in eight shades, is a recent addition to the sanded category and has a very lightly abrasive surface, which is indeed suede-like in texture. It was invented to meet the needs of even the softest pastels and sponge-like blending tools, but it also accepts colored pencil and incising techniques with ease and quick saturation. Suede is a lush surface along which colored pencils move with surprising speed, even while drawing with a light touch and subtle layering.

Ampersand Pastelbord is a permanent museum-quality material which has a light grit made from marble dust. Its subtly sanded clay- and gesso-coated surface is prepared on each board individually. The aspen base provides a non-warping backing board, which makes Pastelbord easy to transport and to carry outdoors for plein air sessions. Pastelbord comes in four hues: white, gray, sand, and green, and is also pH neutral and non-yellowing. White Pastelbord can even be custom-tinted with watercolor pencils for a differently colored base layer. Although its tooth feels lightly sanded, it accepts a surprising number of colored pencil layers and holds up well to lifting with an electric eraser.

Canson Touch, available in fourteen shades and with a very lightly sanded surface, contains an acrylic

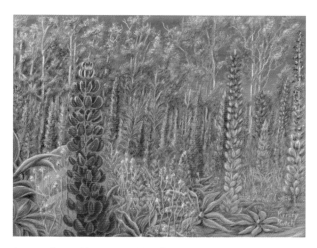

Lupine Lane, Kristy Ann Kutch, CPSA, 2012, 14" x 11", colored pencil, watercolor pencil, and water-soluble wax pastel on Pastelbord.

Lupine Lane is based on a summer scene by a remote Minnesota cabin where my family often gathers. I wanted to capture the blue sky, the birch trees in the background, the granite boulder, and especially the stunning color of the lupines. I drew the sky and background birches with Luminance permanent pencils on green Pastelbord and gradually moved forward in the scene. Eventually I decided that the lupines and other wildflowers needed the extra "punch" of water-soluble pencils and wax pastels. Although I sprayed the finished piece with a fixative, the grated tiny white flowers started to fall off the board, so I used a heat gun to successfully bond them to the Pastelbord. (To learn more about heat guns, please see page 66.)

and silica blend. Touch accepts a variety of art media, including permanent, waxy pencils and aquarelle products. Available as either a paper or board, Touch offers the artist versatile durability. The board is sturdy enough for plein air sessions and the paper—although it is heavy—can be cut with scissors.

Clairefontaine Pastelmat features a very fine cellulose fiber surface coating which feels like delicate velour. The base of Pastelmat is a stiff, card-like material, lending the paper rigid support. Its lightfast eight-color selection includes white, grays and tans, but also warm buttercup and sienna. Combining dry and wet colored pencil techniques on Pastelmat is easy, since it also accepts watermedia. Its surface is gentle to blending tools, yet it holds multiple layers of pigment.

FINISHING TOUCHES FOR LIGHTFASTNESS

I use matte, non-glossy UV protectant fixative sprays to safeguard my art against damaging ultraviolet rays. The workable nature of the fixative means that I can still return to the painting after the spray has dried—and I almost always do—to tweak or accent something with a few extra strokes. When I choose framing supplies, I select either conservation glass, which gives 97 percent protection from ultraviolet rays, or museum glass, with its 99 percent UV protection. After investing my time and hard work in a piece, I feel my art deserves these extra measures.

Abrasive Surfaces

For remarkably speedy color concentration, abrasive surfaces are the ultimate choice. Yes, the rugged tooth does wear down the pencil points, but the density and richness of color deposited there make it worth it. The swiftness of color saturation and buildup is astonishing!

From England comes a sanded, gritty pastel paper which has been enthusiastically embraced by colored pencil artists. Fisher 400 paper is available in a creamy ivory shade and has a stiff backing. Layers of colored pencil cling readily and with great intensity to Fisher 400. Eraser-friendly and sturdy, this paper allows color to be lifted cleanly and quickly with a battery-powered eraser.

Beige UArt paper offers the option of an extensive range of seven grits, from the toothiest 240 grit to the finest 800 grit. It is pH neutral, acid-free, and it accepts a variety of solvents. UArt is suitable for multiple layering, as well as a wide range of art mediums. The tooth of UArt paper is durable enough for blending techniques done with a stiff brush—the grain remains affixed to the paper. It comes in sheets, rolls, and is even available mounted to conservation board.

Sanded, highly textured surfaces designed for the pastel medium are also beautifully suited to the colored pencil. Shown here are (left to right, from toothiest to smoothest) Canson Touch paper, original Art Spectrum Colourfix paper, Ampersand Pastelbord, Fisher 400 paper, UArt 800 paper, Art Spectrum Colourfix Suede, and Clairefontaine Pastelmat.

SANDED PASTEL SURFACES FOR COLORED PENCIL

PRODUCT NAME	KEY CHARACTERISTICS
Ampersand Pastelbord	Prepared on actual board, subtly sanded but takes numerous layers
Art Spectrum Colourfix Suede	Subtle, less abrasive version of original Colourfix paper
Art Spectrum original Colourfix paper, board	Medium tooth, available in boards, small or large sheets; very forgiving
Canson Touch paper, board	Moderately sanded, in large sheets; accepts erasing well
Clairefontaine Pastelmat	Fine tooth, card-like paper
Fisher 400 paper	Available in one buff color, very rugged; accepts many layers
UArt paper	Marketed in seven grits, from ultrafine to very toothy

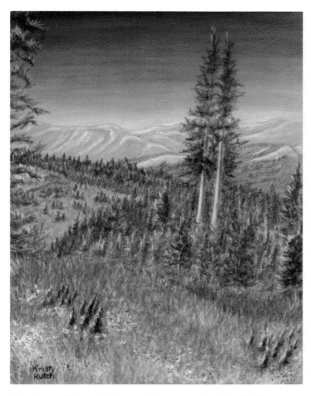

Hurricane Ridge in Bloom, Kristy Ann Kutch, CPSA, 2012, 9" x 12", colored pencil on Art Spectrum Colourfix sanded paper.

I enjoy using a sanded, toned paper or board for landscapes. I applied at least three layers of soft blue Pablo pencils to the sky, warmed it with a heat gun, and blended it into smoothness with a stiff-bristled pastel brush. (To learn more about heat guns, see page 66.) I drew the land features with colored pencils and drew the brightly colored patches of flowers with watercolor pencils, carefully wetted with the tip of a fine brush.

Art Spectrum Colourfix paper and Plein Air board, available in twenty shades, are very durable and toothy grounds. Their abrasive surfaces of acrylic, blended with ground mica, are screened on each watercolor paper and board. Blending waxy pigment with heat and a stiff brush works beautifully on Colourfix. Whether in paper or board form, it takes the pigment quickly and with remarkable intensity. Erasing—even repeated battery-powered erasing in the same place—does not scar the surface nor damage the tooth. For the artist desiring even heavier layering, Art Spectrum also offers silica-coated white Colourfix Supertooth, with a "50% more aggressively toothy surface."

NOVELTY SURFACES

Novelty papers—a paper surface which is not *necessarily* a traditional cotton-based product—are worth exploring as colored pencil surfaces, both for the attractive effects and for the artistic "stretch" they can elicit. I learned about drafting film many years ago from Bet Borgeson's book *Color Drawing Workshop* (Watson-Guptill, 1984). Although she used Mylar and I chose different translucent films, there are appealing similarities in how the surface accepts colored pencil, readily yielding dense, rich color. I was also intrigued by a display of Real Wood paper in an art-supply store and thought that the wood grain might provide its own unique background, with no two sheets exactly alike. I learned that drafting films and Real Wood paper are worthy of experimentation. They not only offer the fun factor of

trying something new, but all of these novelty surfaces take the color quickly, requiring less layering time.

Drafting Films

Sheer Heaven resembles a translucent drafting vellum film, and the distributor states that it can even be soaked or dyed without being damaged. It does not buckle, warp, or wrinkle, and can be cut with scissors. With its etched tooth, Sheer Heaven accepts multiple layers of either waxy or water-soluble colored pencils. (Non-watercolor pencils do tend to smudge and lift a little after about six layers.) Since both sides accept media, there is even the option of tinting the back of the sheet—wet or dry—and drawing on the front, thus giving a softly translucent effect.

Clearprint Vellum 1025 is an exceptional translucent drafting vellum, often found with drafting and reprographic supplies. Being 100 percent cotton, a surprising fact, Clearprint Vellum is pure and acid-free, and much sturdier than heavy tracing paper, which it initially resembles. Allowing about five or six colored pencil layers, on either or both sides, Clearprint Vellum permits very rich color saturation and works up speedily. It features completely consistent, evenly dense formation of the paper and has surface sizing. To protect the art surface, be certain to have a clean pad of paper or other smooth surface underneath the vellum. Check often to clear away any eraser debris or colored pencil fragments, lest marks from the crumbs appear through the film and affect the art layers. Erasing Clearprint Vellum is easy, clean, and forgiving, with no staining.

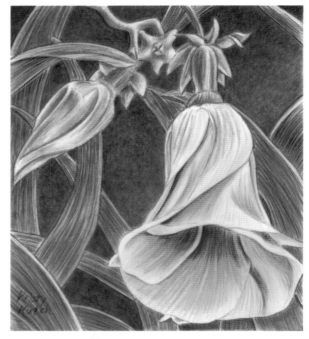

Peachy Bell, Kristy Ann Kutch, CPSA, 2013, 8" x 10", colored pencil on Sheer Heaven film.

Using this West Indies flower as a reference, I was curious about how Sheer Heaven, a surface new to me, would accept colored pencil. The pigment worked up quickly and I enhanced the coral hues of the blossom by repeating some of its colors on the backside of the film. It was very easy to blend the background with a soft handkerchief.

Real Wood Paper

Yet another interesting art surface is Real Wood paper. The surface comes in birch, cedar, cherry, maple, oak, and walnut. The slender sheets of wood veneer can be purchased in either thick or thin varieties and in several sizes, the largest being 12 by 12 inches. Real Wood may curl a bit, but this is not a serious concern and does not interfere with framing. It offers intriguing possibilities for wildlife studies or other outdoor-themed subjects.

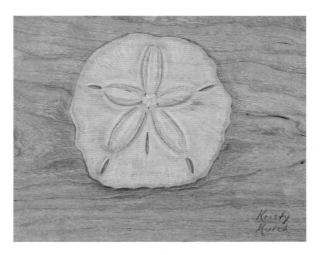

Sand Dollar, Kristy Ann Kutch, CPSA, 2013, 12" x 9¹/₂", colored pencil on cherry finish Real Wood paper.

This sand dollar was my first venture on Real Wood paper. I was surprised that I could easily use a stylus to incise lines and layer so many applications of dense color, creating stark whites. I liked the way the wood grain remained apparent for a natural, somewhat wavy background.

Real Wood paper, another new product, is indeed a very thin sheet of wood and offers an intriguing surface to explore. Translucent papers and films are not exclusively for drafting. They accept several layers of colored pencil and erase cleanly. From left to right: Real Wood paper in cherry, Gallery Different Paper Arts / Cre8it! Sheer Heaven, and Clearprint Vellum 1025.

3 GETTING THE MOST OUT OF COLOR

UNDERSTANDING COLOR IS VITAL TO THE ARTIST.
Whether it is a humble apple or a mountain landscape, the key to creating a realistic, appealing subject lies within a basic knowledge of value and color theory. Color adds zest to life and to art. A drawing or painting without consideration of value—the range from light to dark—leaves the subject flat, without dimension, and it simply resembles a preliminary sketch, no matter how skillfully it is drawn.

This chapter includes a brief history of color theory and a discussion of the color wheel. Even a novice can approach the whole process of drawing in color, beginning with a grasp of light-to-dark values, and moving on to characteristics of colors (whether they are warm or cool, complementary or analogous, single colors or harmoniously layered). From the first cautious strokes to that last finishing touch, the color drawing process does indeed result in a *painting*.

Harley, Jeannette Swisher Buckley, CPSA, 2004, 19" x 24", colored pencil on museum board.

In this beautiful portrait of her granddaughter Harley, Jeannette Swisher Buckley reverses the usual practice of cools in the distance and warm colors in the foreground. Deep violet shadows close to the viewer lend a very effective contrast to the rosy, warm light behind Harley. Sun-kissed highlights, especially on her hair, add an almost angelic aura.

A BRIEF TOUR AROUND THE COLOR WHEEL

The primary colors—red, blue, and yellow—are the building blocks of color, the hues from which the others are derived by mixing them in various proportions. (*Hue* simply refers to the color itself and is used interchangeably with *color*.) Practice color mixing by making swatches on spare sheets of paper or in sketchbooks to become familiar with color layering and effective combinations. Even casual doodle experiments yield some helpful color recipes. It can be confusing to remember whether it was crimson, carmine, or scarlet which helped to yield a certain hue. Be sure to record the colored pencil names and brands so that such mixtures can easily be reproduced.

After experience with such layering, color mixing gradually becomes more intuitive and favorite combinations come more naturally.

Combining yellow with red—depending on proportions—results in some hue of orange. Likewise, a mixture of red and blue produces a shade within the violet range. Mixing blue and yellow yields some shade of green. Orange, violet, and green are the secondary colors, produced by mixing the primaries.

Mixing a secondary color with its analogous, or adjacent, color results in a tertiary color. Such tertiaries are yellow-orange, red-orange, red-violet, violet-blue,

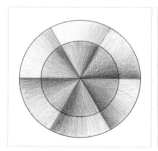 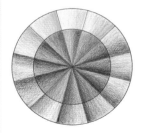

LEFT: The six-hue color wheel includes yellow at the top, followed clockwise by green, blue, violet, red, and orange. Primary colors are yellow, blue, and red. Secondary colors are green, violet, and orange. Complements are direct opposites on the color wheel, such as yellow and violet. Observe the overlapping complementary colors toward the center of the wheel and the vibrant neutral colors they create.

RIGHT: The twelve-hue color wheel shows the tertiary colors: yellow-orange, red-orange, red-violet, violet-blue, blue-green, and yellow-green. Note the overlapping complementary colors between the inner spokes of the wheel and the lively neutral colors they create.

Keeping a record of the names of colors makes it easier to return to a drawing or painting, eliminating the guesswork about which colors were used.

blue-green, and yellow-green. Finding their opposite spokes on the color wheel, it is easy to determine the complements of the tertiary colors, too.

UNDERSTANDING VALUE

Value refers to the gradation of light to dark, no matter what the colors involved may be. It is vital to have a good grasp of values, since they can accurately convey the image from the brightest highlights down to the deepest, most dramatic shadows. Artists often study their photo references first as black-and-white images, to have a better grasp of the light and dark values involved before even applying color. A simple black-and-white photocopy or a grayscale image from a computer program can help as a value study to distinguish values, regardless of colors.

Sometimes artists use a red cellophane viewer to analyze a subject, since it isolates the values without

actually revealing the different colors. This is an effective way of knowing where—even before the colored pencil strokes have been drawn—the lightest of the light areas should be and where to punch up and emphasize the darks.

Jana Westhusing based her piece, *Kansas Clothesline*, on this black-and-white photograph she took when visiting her grandfather in 1991.

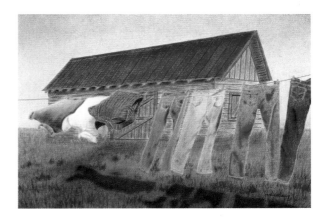

Kansas Clothesline, Jana Westhusing, 2010, 11" x 14", colored pencil on Stonehenge paper.

Part of the challenge for the artist was to recall the wonderful colors that she could see blowing in the wind in her mind's eye. By studying the lights, darks, and intermediate values of the black-and-white picture, Jana gained a grasp of what areas should have deeper, darker emphasis and where the highlights should be, regardless of the colors she chose.

LEFT: Interpreting values of light, medium, and dark is easy with a black-and-white photocopy.

RIGHT: A red cellophane value finder is another tool for discerning values.

Creating Value Range

Values can usually be shown by using the lighter or darker version of the same color to render a variety of light and dark areas—highlights to deep shadowy parts—of a subject. (Value range is more difficult to create with yellows, which are a special case.) Using less pressure—or even reserving the white of the paper to convey highlights—renders a lighter value. More aggressive, heavier pencil strokes usually render darker values.

Monochromatic art involves the extensive use of shades and values from a color family in the same

LEFT: Pencil pressure can range from light and delicate to heavy and intense.

RIGHT: A large set of colored pencils includes a range of values and hues from the same color family.

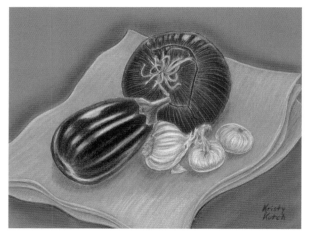

Onions and Eggplant, Kristy Ann Kutch, CPSA, 2013, 11⁷/₈" x 9¹/₂", colored pencil on Canson Touch sanded paper.

The eggplant, with its shine and rich, dark violet surface, provides great highlights as well as smooth, deep values. Onions and garlic, too, offer shimmer and luster, as well as those delicate fine lines in their papery skin. I considered it a personal challenge to get bright, light values, since I rarely use toned paper as dark as this twilight color. Faber-Castell Polychromos pencils, which are very dense and blendable, allowed me to achieve a broad value range and smooth effects on the cloth and in the background.

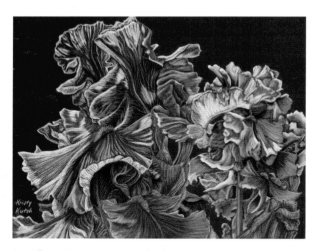

Iris Flurry, Kristy Ann Kutch, CPSA, 2012, 15" x 12", colored pencil and watercolor pencil on Art Spectrum Colourfix Suede.

Different values of the same color can be used for a monochromatic effect. I used a range of violet shades—from a very light violet to the deepest black grape—to create this floral painting.

painting. From pale powder blue to deep indigo or ivory to darkest sepia, the monochromatic palette requires a grasp of values as applied to that hue and its range of variations. Far from dull, the monochromatic work can be dramatic and elegant.

With so many colored pencil hues available, one can select lighter or darker values by using an appropriate version of the chosen color. For example, one can choose from the range of blues, from a very light powder blue to true blue to a deep, dark indigo blue.

LEFT: Color saturation is easily intensified with heavy pressure of a highly pigmented pencil.

RIGHT: The choice of a surface also affects saturation, since pigment clings more densely to toothy, sanded surfaces such as Art Spectrum Colourfix paper shown here.

OTHER KEY COLOR PRINCIPLES

Color application involves other considerations, too, such as saturation for rich intensity. Likewise, it is very helpful to understand warm and cool colors and how they interact; just a few strategic strokes of the right temperature hue can help bring your art to life.

Saturation (or Chroma)

Color saturation (also called chroma or chromation) conveys the brilliance of the color used. Saturation is largely dependent on the art surface, the pressure of the artist's pencil strokes, and the percentage of pigment and art wax in each pencil. (A higher percentage of pigment yields more intense color quality and a higher wax content makes the pigment adhere more to the surface.) Stroking colored pencil onto a toothy surface such as museum board or the rather abrasive sanded pastel papers also gives speedy and dense saturation.

Color Temperature

Artists often refer to warm colors and cool colors and the push-pull dynamic involved with them. Cool colors generally include blue, violet, blue-green, and violet-red like burgundy or wine hues. Warm colors, on the other hand, are thought to be yellow, red, orange, and yellow-green, like chartreuse. Think of the wintery shadows of violet, mauve, and blue on the snow to help recall cool colors. Think of fire to conjure warm shades like orange, yellow, and red.

Hues that are cool give the visual impression of receding and denote distance from the viewer, like a cool and hazy mountain range tinged with a blue or violet cast. This is also true of a light layer or veil of cool color applied over a subject, like a green forest with hazy blue over the more distant trees. Meanwhile, warm colors give the impression of coming forward or advancement, like golden sunlit wheat in the foreground of a landscape. Likewise, applying even a subtle layer of a warm color, like yellow or golden ocher,

warms up the subject and makes it appear to be closer to the viewer. (To help remember the effects of cool and warm colors, think of an aloof, cool, and distant person versus an approachable person with a warm personality.) Keep in mind that such a layer of cool or warm color can be very light and subtle, not a heavy-handed application of colored pencil.

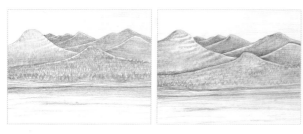

LEFT: A green mountain range looks fairly flat, without much sense of dimension.

RIGHT: Adding a cool color like a soft blue lends a haze and a sense of distance to the most remote mountains.

LEFT: A grassy field looks flat and monotonous when only sketched in green.

RIGHT: Compare this field to the previous image. Note that adding burnt carmine, a cool color, and golden ocher, a warm hue, changed this to a more realistic, dimensional field.

LAYERS OF POSSIBILITIES

It can be convenient and fun to have dozens of pencil colors, but consider, too, that layering colors can create a harmony more complex and subtly pleasing than a simple melody. This is reassuring for the person who starts with a basic collection of 24 colors. The mixing potential of those colors is surprising, yielding a large range of blended hues.

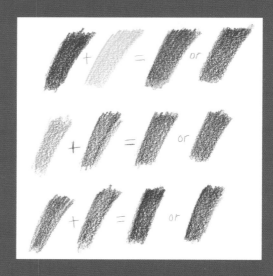

COMBINATIONS OF BLENDED COLORS LEND HARMONY AND ARE SOMETIMES MORE VISUALLY INTERESTING THAN SIMPLY USING A PENCIL OF THE DESIRED COLOR.

PLAYING WITH COLOR CONTRAST

Color contrast lends spark and interest to a piece and often makes the observer do a double-take. Touches of a complementary color layered in an area, for example, add vibrant appeal. I often add such strokes as I finish a painting, as if I've been dared to do it, and that color play always adds a little zest.

Simultaneous Contrast

Positioning two complements next to each other actually intensifies them by virtue of a principle known as simultaneous contrast. Though we rarely think about it on a conscious level, we encounter these striking color combinations all the time—red for stop and green for go on a traffic light, deep blue Delft china with orange accents, or yellow and a mix of yellow and purple wildflowers along the roadside.

Sometimes this simultaneous contrast is as subtle as a few light strokes of a color added alongside its complement. In *Glorious Twining*, note the large blue morning glory on the left. Examining it closely, look for evidence of orange strokes visible in some of the deep blue areas. Although they are not bold and obvious—most of them are barely visible among the blue—these touches of the complementary orange add to the dynamic of the blue flowers. Again, this is an example of the vibrant play of simultaneous contrast with complementary colors.

Glorious Twining, Kristy Ann Kutch, CPSA, 2007, 15" x 12", colored pencil on 4-ply Rising museum board.

This detail of the flower on the left in *Glorious Twining* reveals the subtle complementary orange streaks in the petals, which add a spark to the vibrant blue colors of the blossom.

Layering Complements

Layering two complements *over* each other yields a lively neutral hue which is much more energetic and visually interesting than using a flat gray. This is especially true for creating neutrals with the relative transparency of the colored pencil medium. A complementary color, whether used in an underpainting (an initial layer of color laid down before application of other colors) or added later, gives vibrant depth and dimension to a subject. Despite the name, keep in mind that underpainting can be done with dry colored

pencil, too, not just with water-soluble "painterly" media. Creating an underpainting first can help create dimensions and shadows even before the actual colors are applied.

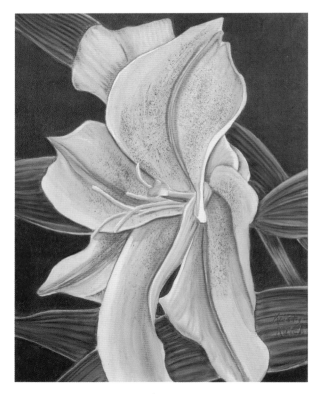

Newport Lily, Kristy Ann Kutch, CPSA, 2013, 12" x 16", colored pencil and watercolor pencil on Colourfix plein air board.

Newport Lily features the use of complementary colors, with reddish violet underneath the deep green background and a light application of green underneath the pink petals. The green underpainting on the petals is not obvious, but it adds depth and dimension nonetheless.

Creating Realistic Effects with Complementary Colors

The color wheel offers a technique for creating a three-dimensional effect in a piece, adding depth and a vibrant interplay of complementary colors. In *Garden Treasures*, I began by layering the shadows of all of the yellow peony petals with very light values of violet, the complement of the yellow peony blossoms. (I used dry violet colored pencil for some petal shadows but

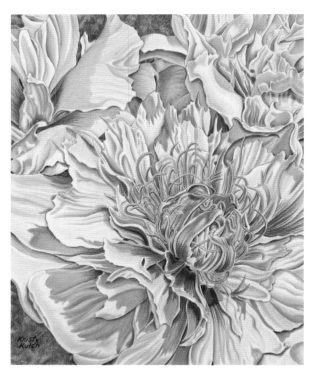

Garden Treasures, Kristy Kutch, CPSA, 2010, 16" x 20", colored pencil and watercolor pencil on Rising 4-ply museum board.

eventually changed to a very diluted wash of violet watercolor pencil.) Before I added the yellows, this painting looked like a study done entirely in violet and burgundy red (a complement of the green features). I found that modeling the yellow petals with a subtle violet complement was a livelier, richer alternative to simply creating the darker areas on the petals with a light brown, for example.

Combining Warm, Cool, and Complementary Colors

Considering warm and cool color concepts and implementing the principle of complementary colors can do wonders to improve an otherwise flat colored pencil rendering, taking it from simple sketch to dynamic painting. Students in my workshops often fret because their drawings appear flat in color and unappealing. But often these efforts are simply works-in-progress that show great potential.

One frustrated student complained that even after hours of work, her carefully drawn trees still resembled "green lollipops." With a few well-chosen strokes of a burgundy hue, Tuscan red, a complement of green, she added the darkest shadows within the deepest leafy areas. She then added more dark greens, which made the depth of the foliage much more striking. She finished by putting down some strokes of yellow and cream on the closer sunlit parts of the boughs, making them appear more three-dimensional. After applying some complementary and warm/cool color theory, the trees looked quite realistic. It simply took a few minutes of tweaking the colors.

TOP: Trees drawn in shades of green show some values of lights to darks.

BOTTOM: Adding a complementary color of a dark, cool red does wonders for making the dark greens look deeper and more intense.

4 APPLYING AND LIFTING WAXY COLORED PENCIL

make mistakes with colored pencil!" But she was wrong. Happily, colored pencil is a remarkably forgiving medium, allowing erasing, lifting, and tweaking. Such lifting potential is very liberating, since it enables highlighting, which enhances values. Experience and confidence help with applying and lifting colored pencil on one's own art.

COLORED PENCIL TECHNIQUES HAVE GENERALLY been straightforward: stroke on the color (stroke directions vary from artist to artist), try to use layers of controlled pressure rather than aggressive strokes, and enjoy the journey as well as the destination. Saturated, vivid colors can be achieved with the help of more layering, heavier pencil pressure, and/or the use of commercial blending products (several new lines of blending pencils having appeared in recent years). Artists have developed novel approaches for applying colored pencil pigment and widening the range of values. The results can be delicate and light or dense and painterly.

Admittedly, one of the first questions I asked my first colored pencil instructor was, "How do I erase this?" Her solemn reply was, "You just don't

His and Hers Hats 1, Barbara Grant, 2012, 10" x 13", colored pencil on Strathmore vellum finish Bristol board.

This painting is the first of a series that Barbara Grant based on friends' photos from a trip to Canada, during which they photographed their cowboy hats every day when they stopped for lunch. Barbara used white, cream, sand, pumpkin orange, clay rose, grayed lavender, light umber, and sienna to make the hats look dimensional and worn. To emphasize the darks in the hats, she added Tuscan red, indigo blue, dark purple, violet, and black grape. Using a stiff blending brush, she vigorously scrubbed yellow chartreuse, chartreuse, lemon yellow, Tuscan red, bronze, artichoke, and warm French gray to achieve the leafy background.

PREPARING BASIC LINE DRAWINGS

A line drawing provides the skeleton for your painting. So before you go putting meat on those bones (i.e., applying color), or taking it away (i.e., lifting color), it's important to create the framework. There are a number of ways to go about making a line drawing, depending on your subject, comfort level with drawing, and personal preference.

Thumbnail and Freehand Sketching

Some artists begin by collecting quick, simple thumbnail sketches of their subjects and then develop one—or a combination of them—into a composition. Others develop an eye for drawing freehand by simply looking at the subject and sketching its likeness directly on the art surface, whether it is a plein air landscape or a still-life composition.

Thumbnail sketches are quick studies which help develop a line drawing for a composition.

For the sketching and early line-drawing process, a good, translucent paper is very helpful. Although tracing paper works for this purpose, I've found that drafting vellum is excellent. Such papers are sheer, sturdy, and forgiving enough to endure plenty of erasing. Look for them in stores that sell art supplies or drafting materials.

Working from a Photograph

For many artists it is practical to also work from photographs, thus preserving the moment before the sunlight shifts, the model becomes restless, or the flowers wilt. Digital cameras allow you to quickly capture many images and easily keep the best while deleting the rest. Do not hesitate to crop the image when deciding how much to draw; it is not necessary—and often not even desirable—to draw *everything* you see in

 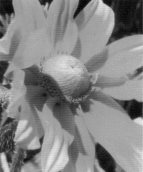

LEFT: These flowers were in a large sidewalk planter, reflecting glorious July sunlight.

RIGHT: Cropping the image to one bloom simplifies the image.

the reference photo. There is beauty in portraying the subject at close range, eliminating the extras, pulling in, and drawing a tighter, more essential view.

Tracing an Image

Tracing an object through a light box or the pane of a sunny window is one way to capture the basic outline of an image. Another means is to directly trace the outline of a photo image, using translucent drafting paper or heavy tracing paper placed over the photo. Then the image can be copied onto the actual ground (or art surface) by using transfer paper, a coated paper that transfers a traced image onto the new surface. The same sheet of transfer paper can be used many times on various drawings, still giving a very good line.

Such a tracing process—similar to using carbon paper to make a carbon copy—is not considered a violation of the rules, nor is it considered unethical (as long as you trace your *own* line drawing or photograph). How the basic line drawing is created is a matter of personal preference.

Using the Grid Method

There is great satisfaction in drawing something freehand by looking and sketching to capture a likeness. When the subject appears intricate or difficult to keep in proportion, the grid approach is helpful and still gives the artist the satisfaction of having drawn the subject, rather than having traced it through a light box, for example. The great artists Leonardo da Vinci, Leon Battista Alberti, and Albrecht Dürer all devised and used versions of the grid method for accuracy and perspective in their drawings.

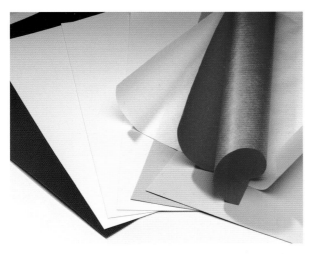

Transfer paper is ideal for copying a line drawing to the actual art surface.

How to Use the Grid Method

Once I've selected part of a photograph and cropped it down to the essential part that intrigues me, I often develop a drawing by using a grid. I start by making a color photocopy or enlargement of the reference. The color quality may not equal that of the original photo, but it is still a helpful, detailed reference and takes a few seconds for the photocopier or color printer to do it.

1 With a fine-point permanent marker, I drew a grid of 1-inch squares onto the part of the color photocopy to be used as a reference. (Clear acetate sheets can be found which have the squares pre-drawn. Such a sheet simply rests on the reference picture, eliminating the need to draw squares directly onto the photocopy.)

2 Using a ruler, I drew a grid of 1-inch squares on a sheet of Denril Multi-Media Drafting Film sheer overlay paper. Tracing paper would have worked, too. (For a drawing which is intended to be twice as large as the photograph, I would enlarge proportionately and draw 2-inch squares on the overlay paper.) Then I drew (freehand) onto the overlay paper the part of the image that appears in each individual square on the color photocopy. Where there were more intricate areas, I left those squares for another drawing session, when I was fresher and more patient.

3 Once the line drawing was sketched onto the Denril paper, I taped it to the top of the actual art surface, hinge-style, so it flipped freely from the top hinge. I then inserted a sheet of transfer paper, with the brightly colored side down, between the sheer overlay sheet and the art surface. Transfer paper—Saral brand, available in several colors and white—works on the same principle as carbon paper, but is much neater. The same sheet can be used multiple times. In fact, I prefer used transfer paper, since the copied Saral lines are discernible but not too bold.

4 Using a colored pencil—not *too* sharp, since I didn't want to leave impressions in the paper—I traced all of the drawing lines on the overlay paper, pressing down so the transfer paper beneath it copied the drawing. When the overlay and the transfer paper are lifted, the copied lines should be seen on the art surface. This results in a well-proportioned line drawing, ready for color. If the transferred lines look too prominent, like the thick lines of a coloring book, I dab at them with reusable adhesive, sometimes called sticky tack. The adhesive gently lightens the lines, leaving enough to be easily seen as guides.

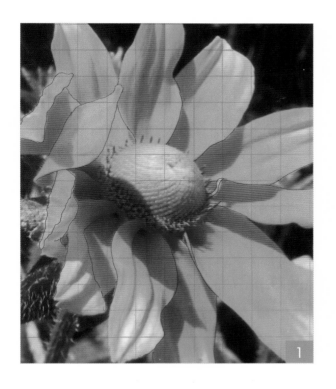

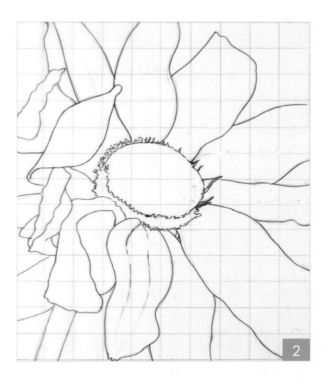

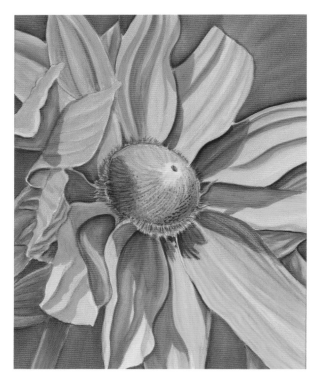

Sunny Splendor, Kristy Ann Kutch, CPSA, 2013, 12" x 15", watercolor pencil on Strathmore Illustration Board for Wet Media.

METHODS FOR APPLYING COLORED PENCIL PIGMENT

Once you finish your line drawing, the fun part—that is, the color—begins.

One benefit of colored pencil is that you can be tentative, using light-pressure layers in the beginning and building up the layers as you gain momentum. Although I have been working in colored pencil for more than twenty-five years, I still "test the waters" when I begin to stroke on the color. Usually I begin with an element like a small background flower or leaf. As I gain more confidence and experience with my subject matter and handling of color, I move to the more prominent parts of the composition.

There are a host of methods for actually applying colored pencil to a surface, depending on the effects you want achieve.

Varying Pencil Pressure and Sharpness

Since artist-grade colored pencils are so highly pigmented and sensitive to hand pressure, strokes can easily deliver anything from light and delicate colors to surprisingly heavy, saturated hues. You can render different effects, from the very obvious lines of a highly sharpened pencil point to the broader layering made by using the side of the pencil core or "lead." Practice various stroke pressures from very subtle to heavy and compare the results. Likewise, note the difference between the effects of a sharp pencil point and the broad, less defined strokes using the side of the pencil. None of these styles is right or wrong; it depends upon the artist's preference and the desired texture of the subject matter.

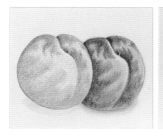

LEFT: The same colors were used on both the left and right peaches, but the peach on the right shows heavier pencil pressure.

RIGHT: Pencil sharpness is a matter of preference and of subject matter. These two Honey Crisp apples show the difference between drawing with a sharp pencil point (left apple) and with the side of the pencil, which is broad and blunt (right apple).

Cherry Delight, Ranjini Venkatachari, CPSA, 2011, 14" x 11", water-soluble wax pastel and colored pencil on Pastelbord. Collection of Jerry and Darlene McNaul.

Ranjini prefers Ampersand Pastelbord as a support. She enjoys its layering potential, applying water-soluble wax pastel, washing it, and letting it dry overnight. She then adds layers of colored pencils and blends them with a dry bristle brush.

Differentiating Strokes

Stroke preferences vary greatly among artists. Depending upon artistic style and subject matter, there is a place for any or all of the following stroke styles in colored pencil art.

Small, straight vertical lines of a uniform pressure with little or no overlap are especially useful in rendering grasses and wheat fields, effectively mimicking the direction in which such plants grow.

Some artists prefer small, loose circular or oval strokes, which eventually, when layered, mass in even color and help to cover any obvious line direction.

Nicknamed Brillo strokes by colored pencil pioneer Bet Borgeson, these strokes are ideal for portraying smooth objects without revealing the pencil lines. Imagine something smooth and shiny, like a pewter vase or glossy cherries. They are also excellent for rendering softly textured backgrounds. Here are some other types of strokes that can be extremely effective, depending on the circumstances.

LEFT: This barnacle shows the strong use of almost all vertical strokes.

RIGHT: Shiny objects such as cherries look smoother when done with overlapping circular or oval strokes.

Cross-hatching, created by crisscrossing lines in opposite directions—is especially helpful in portraying the texture of heavily woven fabric like burlap.

Curvilinear strokes, which follow the contours of an object, can be appropriate when conveying the curved shape of an apple or the contours of a long and trailing vine.

Scumbling is a form of "educated scribbling" that can help create mass in large areas with gestural lines

and swirls. It is effective for rendering fluttery, leafy boughs of trees or large areas of distant vegetation.

Pointilistic strokes are applied by patiently dotting many pinpoint marks with the pencil tip. Such dots can be used as an Impressionist style of drawing or for rendering the granular textures of sand, gravel, marble, or granite.

Grating the Pencil Point

Colored pencil can take on an entirely different quality when grated into a fine powder. (For an example of grating, see *Grating a Pigment to Create a Soft Vignette* on pages 56–57.) By grating the pencil core through a mesh tea strainer over the art surface (preferably one that is not slick and that has some texture), one can distribute the powder with a blending brush, Sofft pastel sponge applicator, chamois, tissue, or makeup sponge, to quickly create very soft, delicate effects—much like pastel.

This grated technique has opened up new possibilities for depicting soft backgrounds, mist, fog, and delicately graduated shadows in a matter of a few minutes, not hours. It is amazing to see how quickly the colored pencil core changes to a soft powder and how well it can be manipulated and blended in that form.

Lifting, Erasing, and Tweaking Colored Pencil

Beginning artists often fear that even an accidental nudge will cause a "fatal" error, not realizing how well colored pencil can be erased. Happily, there are some effective products for lifting, erasing, and tweaking colored pencil pigment.

TOP, LEFT: The crisscross pattern of cross-hatching lends itself well to depicting woven fabrics.

TOP, RIGHT: This Spanish eggplant shows a good example of curvilinear lines.

BOTTOM, LEFT: Impressionistic scumbled strokes, or educated scribbles, lend themselves well to drawing trees, eliminating the need for the artist to draw every individual branch.

BOTTOM, RIGHT: Pointilistic strokes are ideal for showing the dimpled surface of a lime.

White Vinyl Erasers

These can be rectangular blocks or cartridge-type erasers resembling pencil cores. White vinyl erasers are clean and non-damaging, gently lifting pigment. The cartridge eraser is effective and easily found among school supplies, convenient as a pen. Tombow manufactures Mono Zero pen-style holders and refills; these are unique, with small rectangular or tiny cylindrical tips for very precise and clean erasing.

Vanish Eraser

This convenient chunky product is advertised as a 4-in-1 eraser, suitable for lifting graphite, colored pencil, charcoal, and pastel. It is amazingly gentle, yet effective. Vanish can be sliced into smaller wedges and is unique in that it leaves neat rolls of eraser product, not crumbs. Try it, too, on soiled or smudged areas as a nonabrasive cleaning product.

Battery-operated White Erasers

This zippy motorized eraser whisks through colored pencil. Lifting layers without surface damage, it is the best invention for crisp erasing. As an accessory, a metal eraser shield is an inexpensive guide in lifting well-defined, precise shapes—even pinpoint dots, dashes, and arcs. Gently fluff away the eraser crumbs, since they contain pigment; manually brushing them can cause streaks.

Faber-Castell Perfection Eraser

Looking much like a wood-encased pencil, Faber-Castell's Perfection eraser has an eraser core which easily sharpens in a pencil sharpener. This allows for a fine point and for very precise erasing. Perfection is also available with a brush on the end to whisk away the eraser crumbs.

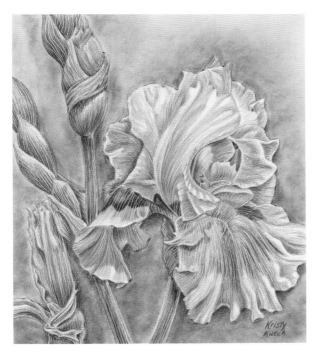

Phyllis' Iris, Kristy Ann Kutch, CPSA, 2011, 11" x 13", colored pencil on Rising 4-ply museum board. Collection of Susan McKillop.

This piece is a tribute to my mother, Phyllis, who was known for her stunning irises. When I started this piece, I had recently learned about grating colored pencil. Even with some tweaking, I completed the violet background in less than an hour.

Grating Pigment to Create a Soft Vignette

With their multiple overlapping layers of concentric petals, roses are especially elegant flowers. When I decided to render this single yellow rose, I knew it needed a subtle, atmospheric background. I used Stonehenge paper for its subtle texture, which is an excellent substrate for the grated-pigment style of background. (By the way, I recommend to my novice students that if they like roses, it is easier to start by drawing a rose bud, or, as in this case, a rose in profile view!)

1 On Cream Stonehenge paper, I made a line drawing of a single yellow rose. Holding a fine metal mesh screen close to the paper surface, I grated a Caran d'Ache Pablo periwinkle pencil so that the pigment dust fell into the background areas.

2 With a tissue (although a spongy blending tool or soft cloth would also do) I gently worked the pigment so that it was blended into a soft cloud of color surrounding the rose like a vignette.

3 To remove background color that I accidentally applied to the rose, I lifted the pigment with a battery eraser and dusted off the eraser debris.

4 I used a light touch of periwinkle (a complement of yellow) to create shadows on the rose petals. With a Pablo dark carmine (a complement of green), I then lightly drew the shadowed areas on the stem and sepals, the green petals which support the rose. I applied a range of yellows and ochers to the petals, concentrating the ochers in the darkest areas. I used khaki green, olive yellow, and dark green on the stem and sepals. Finally, I stroked a sharp lavender Sanford Prismacolor Verithin pencil along the edges.

Yellow Rose, Kristy Ann Kutch, CPSA, 2013, 11⁷/₈" x 9¹/₂",
colored pencil on Stonehenge paper.

Frisket Film

Low-tack frisket film (airbrush art masking film) is a translucent, lightly adhesive film on a paper backing. Peel back the paper and gently apply the sticky side of the film next to the art surface. Set the film over on the area to be lifted. Using a blunt object like a pencil point, rub the area. Gently peel back; the colored pencil has been removed, leaving no paper damage.

Scotch Blue-label Tape

Artist Jonee Paul uses Scotch Removable Tape like frisket film. This is the blue plaid–label variety which conveniently comes in the roll-type dispenser. It is a low-tack (no residue) somewhat clear product which is sold in office-supply stores.

Swirls and Stripes, Kristy Ann Kutch, CPSA, 2013, 12" x 9½", colored pencil on plate-finish Bristol board paper.

I started *Swirls and Stripes* many years ago, and tucked it away, half-finished, in a sketchpad. At that time I did not even own an electric eraser, a must-have for me now. I very belatedly put it to good use, cleaning up edges and lifting out highlights on the red onion and on the shiny fruits.

Masking or Drafting Tape

For lifting purposes, choose the cheapest masking tape with the lowest tack (adhesive). Apply over the place to be lifted, look carefully (since it is not transparent), and rub with a blunt object, peeling back to view the lifted layer. Repeat if more erasure is desired. This tape can also be bunched into a loose wad and dabbed for random texturizing.

Kneaded Eraser

The kneaded eraser, a favorite workhorse, erases graphite cleanly, but it is less effective on colored pencil. It works well for colored pencil texturizing and tweaking. The Lyra Knetgummi kneadable eraser is pliable and has excellent lifting power. As with any kneaded eraser, it should be pulled and stretched to a clean area to prepare for new lifting.

WATCH THOSE CRUMBS!

Since erasers lift and remove pigment, their crumbs have pigment in them, too. I have discovered that a heavy-handed sweep with a drafting brush can actually make little streaks of color. When in doubt, I tap off eraser crumbs or blow them away, sometimes with a compressed air duster. I've also heard that a Swiffer-type hand-duster is excellent for this purpose.

Poster Putty

This reusable adhesive, found among school supplies, has various names, including "sticky tack" or "poster putty." Useful when an artist has become too "heavy-handed," it works by dabbing and lifting, removing successive layers of color and leaving no residue. Store the putty in foil or in a small container. Excellent as an adhesive, that same stickiness seems to attract debris, too.

A wide variety of products can effectively lift colored pencil pigment: 1) low-tack frisket film; 2) masking tape; 3) battery-powered electric eraser; 4) eraser refills; 5) eraser shield (for precise lifting through slots); 6) eraser with small round tip; 7) eraser with fine rectangular tip; 8) reusable putty-like adhesive; 9) white vinyl eraser; 10) kneaded eraser; 11) Vanish eraser; 12) removable cellophane tape.

5 CREATING AND ENHANCING TEXTURES WITH COLORED PENCIL

COLORED PENCIL PAINTING EFFECTS CAN RANGE from airy, light, and delicately textured to densely pigmented, rich, and painterly. Neither approach is right or wrong: it depends on the subject matter and the artist's own taste. Textural effects also depend upon the art surface, pencil pressure, and the tools used for blending—or not blending—the layers of colored pencil.

In recent years there has been an exciting boom in colored pencil innovation. Not only are there new drawing surfaces—ranging from soft and velvety to gritty and sanded—but there are innovative techniques for rendering in colored pencil. Stroke it, grate it, heat it, and/or briskly brush it into the paper or board: the pencil has never offered this many techniques for achieving stunning color.

Brush-blending traditional colored pencil, as pioneered by Bet Borgeson and Linda Lucas Hardy, has offered wonderful potential for dense, jewel-like realism. The development of Ester Roi's heat-blending, utilizing the soft nature of molten-wax and warmed pigment, is revolutionary. The selection of blending pencils has expanded tremendously since the introduction of the first one in the 1990s. There are also more solvent products available for colored pencil. With each passing year, this medium offers new possibilities!

Stumpy, Debbie Bowen, 2012, 11" x 14", colored pencil on Pastelbord.

In this portrait of her family's adored family pet, Stumpy, Debbie Bowen used twenty-eight layers of color for the fur. With each application, she used very stiff brushes for blending, and she added the fine hair detail with the last few layers of color. She used Pastelbord because it easily accommodated the many layers of color and Polychromos pencils because of their unique blending power.

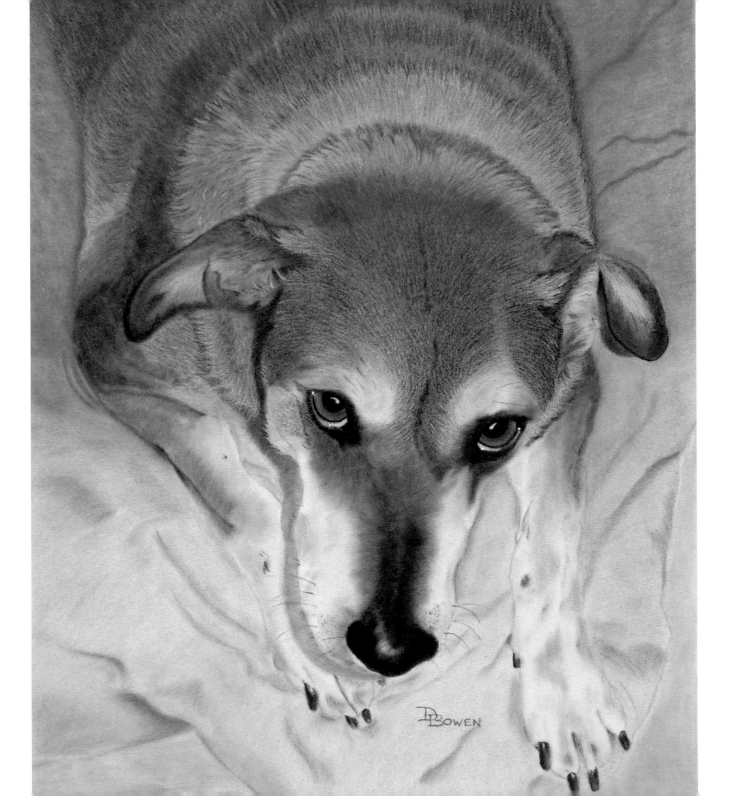

STRATEGIES FOR BLENDING

Sometimes when I'm working on a piece, I want to simply use straight color, just as it strokes from the pencil. More often, though, I like to layer colors and blend them for character and color harmony. Blending can mean patiently overlapping layers or it can involve heavily applying colors, possibly even filling in the tooth of the paper with a blending product, for a slick, shiny finish. It depends on my subject matter and the results I desire.

Blending with Layers

Blending can be done by patient and subtle application of overlapping colored pencil layers, sometimes as many as the paper or board can accept. Because colored pencil lightly stroked is not opaque, the combination of underlying and top colors lends a subtle visual blending effect. A soft layering approach often adds more interest than simply choosing one color. Such a scheme of overlapping colors can also enhance the color unity and harmony when a common hue in different color combinations is used in the same piece.

Delicate, soft effects literally go hand in hand with patient layering, using light stroke pressure. It may take practice and restraint to develop the control of a light touch, applying successive layers and avoiding a heavy hand. Artist-quality colored pencils are so loaded with color that it may be tempting for the new artist to take the plunge and quickly fill up the tooth of the paper with heavy pressure and dense pigment.

This kind of speedy density, though, is difficult to lift or erase, leaving the art surface saturated to the point where it simply cannot accept another layer of pigment. At saturation stage, any new colored pencil layer literally slides off the paper, leaving no new pigment. The only solutions are to lift and undo some layers (to allow more tweaking) or to spray with a workable fixative before adding additional layers. Once thoroughly dried, the fixative creates an extended tooth on the art surface, lending enough texture to add another layer or two of pigment.

Some texture, even if it is subtle, is needed to accept multiple layers of pigment. This is why it is preferable to use paper with a subtle tooth or a velvety surface, like Stonehenge or Revere silk paper. Museum board and vellum-finish (not plate-finish) Bristol board are also ideal for rendering glossy subjects. Since they are not obviously textured, the artist need not struggle with the flecked tooth of the paper to achieve smooth, dense color.

Blending with Solvents

Creating smooth, dense textures which reveal little or no tooth of the paper can be challenging. Solvents can help. Various fluid solvents work to dissolve the binders and release smooth colored pencil pigment, lending a painterly result quickly. When using solvents, such as odorless mineral spirits or rubber cement thinner, be proactive by noting toxicity warnings and taking safety measures. ("Odorless" does not

mean nontoxic.) While such products are effective, it is advisable to look for safer alternatives among solvents. I avoid using odorless mineral spirits and rubber cement thinner, due to their toxic ingredients.

Gentle, less hazardous blending products include clear, fast-drying solvents in double-ended applicators. These liquid solvent markers are convenient tools for blending and dissolving pigment into a smooth coat of color. However, I have learned that they do have some quirks. Make sure to test any colors in the purple or magenta family on scrap paper first. Prismacolor dark purple and lilac, for example, react with the Prismacolor Colorless Blender marker to yield a strong pinkish hue.

Beneath the Gates Mills Bridge, Mary G. Hobbs, CPSA, 2008, 23" x 32", colored pencil and solvent on 5115 watercolor 4-ply mat board.

Mary Hobbs was inspired by this scene on an autumn walk. The leaves, steeple, and water were so magnificent that she snapped a photo and used it as her reference. Using a cotton swab, Mary brushed Turpenoid solvent onto each successive layer of colored pencil. This smoothed the watery colors, lending a fluid appearance.

Economical and less harmful solvent blenders include (from left to right) the Finesse Blender Pen, Sanford's Prismacolor Colorless Blender Marker, and the Tombow Dual Brush-Pen Blender. The alcohol-based solvents work by dissolving the binder to make colored pencil pigment look smooth and fluid, and they tend to dry with a matte finish.

Blending and Burnishing

Blending involves successive layering to achieve a translucent mixture of hues, much like an interesting color harmony. Burnishing, on the other hand, involves blending with heavy stroke pressure and a white (or very light) colored pencil. Imagine a color sandwich, with layered pigment, then heavy pressure with a white colored pencil, followed by even more pigment. Such stroke pressure and color sequence cause a melding of layers to fill in the tooth of the paper, creating a shimmery density of color. Burnishing is the painterly process which often makes astonished viewers doubt that an artwork was actually done in colored pencil.

Blending and Burnishing Pencils

Blending pencils and burnishing pencils are non-toxic, portable, and convenient, and help you quickly achieve smooth, rich effects. They also do not lighten the dark values with a milky effect when used for burnishing very deep colors. The world of manual blending and burnishing pencils has greatly expanded since Lyra's introduction of the still-excellent Splender in the late 1990s.

Derwent markets both Derwent Blending Pencils and Burnishing Pencils, two separate products for smoothing the layers of colored pencil to create saturated, shimmery, jewel-like color. Caran d'Ache has introduced a concentrated, hexagonal (less likely to

This series of pomegranates shows the progression of burnishing with a blending pencil. On the left is a simple application of colored pencil strokes; the middle fruit features the same colors topped with a heavy-pressure, burnished layer of blending pencil. Finally, the pomegranate on the right, the most vivid, illustrates the effect of layering colored pencil over the burnished layer.

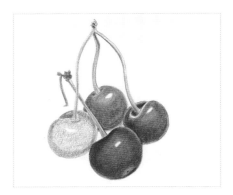

In this cherry quartet, the fruit on the far left shows a simple layer of unblended colored pencil. Moving clockwise, the fruit on the top shows the effects of a Tombow liquid solvent brush-blending pen. In the cherry on the right, another layer of color pencil was added over the dried solvent blending. Finally, the fruit on the bottom shows the shimmery nature of yet another step, adding a layering of blending pencil for gloss.

roll off the drawing table), woodless tapered blending rod, the Full Blender Bright. The manufacturer notes that where the Full Blender Bright has been applied, the art becomes glossy and water-resistant. Sanford Prismacolor offers blending pencils as both traditional wood-cased pencils and stick-like rods resembling pastel sticks.

Combining Blending Solvents and Burnishing Pencils

The blending advantages of both speedy solvent liquids and glossy burnishing pencils can be combined in the same area. I have found this combination very useful when I want to overcome and densely fill in the tooth of the paper. This pairing is effective for rendering very glossy subjects, such as cherries or highly polished surfaces.

I begin by layering the colored pencil pigment, followed by stroking or brushing on solvent for a fluid-looking base coat. After allowing that to dry—alcohol solvents dry almost immediately—I stroke on more colored pencil layers. I then burnish the surface with heavy pressure, followed by still more colored pencil layers. I sometimes even repeat the process with more sandwiched layers of pigment, burnishing pencil, and pigment.

Blending with Brushes and Sponges

Blending colored pencil with brushes and sponges is a relatively new and incredibly useful technique. By using an inexpensive hog-bristle brush, you can literally massage the drawn-on waxy pigment of colored pencil into the paper surface. You can do the same with a pastel blending brush, the bristles of which have been

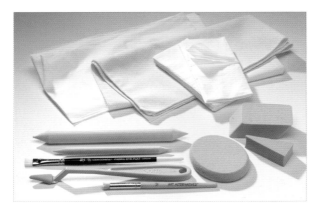

Blending tools for colored pencil help to render softer, smoother color.

Brush-blending scrubs the pigment directly down into the tooth of the paper or board.

trimmed short, as recommended by artist Linda Lucas Hardy. The stiffer and stubbier the brush is, the closer it can get to the art surface and the more effectively it can work the color into the art ground. Because of the intensity and friction involved with such vigorous brush-blending, the pigment is literally scrubbed into the art surface, yielding richly intense colors.

For blending with a lighter touch, a new line of washable sponge-like tools called Sofft is available. Originally created for soft pastels on velvety surfaces like Pastelmat or Colourfix Suede paper, Sofft tools are ideal for blending either smudgy colored pencils or grated, powdered colored pencil pigment. Sofft tools are offered in a variety of shapes and sizes—ovals, wedges, tiny knife-shaped sponges—that are great for blending everything from large sweeps of color to smaller, more detailed areas.

Blending with Heat

Artist Ester Roi invented the revolutionary and highly effective heated Icarus Board. The Icarus Drawing Board features a thermostatically controlled side for safely melting and blending the waxy colored pencil layers and a cooler side for detail work and precise drawing, speeding and intensifying the entire blending process. Waxy "traditional" colored pencils, wax pastels, or crayons can be heated and blended with the Icarus Drawing Board. For safety reasons, no solvents are involved and the manual blending is done with any tool that works: blending stomp, tortillon, color shaper, or cloth. Colors emerge as vivid, jewel-like and stunning, all done through this nontoxic heat process.

If an Icarus Drawing Board is not an option, you can use a heat gun. Heat guns can be found at craft stores, usually among embossing supplies, as well as at hardware stores. Although the heat gun does not offer the advantage of warming a large area all at once like the Icarus Drawing Board, it can effectively heat smaller areas of colored pencil pigment. (A hair dryer

BUDGET-FRIENDLY BLENDING TOOLS

Stomps and tortillons are great art bargains; these cheap tools for blending come in a wide range of sizes, too. A stomp is a cylindrical, densely pressed cardboard rod, like a light gray cigar with pointed ends. Although I use stomps for their smooth, consistent surface, tortillons—which tend to be smaller—are also available as blending tools. The tortillon is pointed, too, but is made up of tightly rolled paper which can be unwound to a clean area. Originally used by pastelists and artists who work in charcoal, stomps and tortillons have been adopted by colored pencil artists, as tools helpful for manual blending (with heavy pressure), depending on the kind of colored pencil and how smudgy and blendable it is. These tools work well with soft or smudgy pencils, whether they are grated or softened with heat from either an Icarus Drawing Board or a heat gun.

Clean a stomp by brushing it against an emery board or sandpaper until the smudge is gone.

does not provide enough concentrated heat for this process.)

If the gun has several settings, be cautious and start at the lowest temperature, carefully experimenting with various settings. Continuously move the heat gun over the layered pigment, keeping the heat source very close (1 inch from the surface) so that the color becomes molten. Once the colored pencil layers have been warmed enough—and this may take practice and repetition—the wax softens and the color can be blended quite smoothly. Using a stomp or stiff hog-bristle brush to massage the soft pigment into the paper or board, the color becomes rich and dense.

Colored pencil pigment can also be grated and then warmed with brief but intense heat application with a heat gun. This actually melts the unblended, grated pigment onto the art surface, creating distant dotted fields of flowers, snowflakes, sand, or gravel, to name a few possibilities.

Heat guns work well with stuff brushes to soften and blend colored pencil layers.

CREATING DRAMATIC TEXTURE

Colored pencil painting is just like life—in some cases it's better to blend, in others it's better to make a statement. Textural interest can make or break a painting, whatever the medium. Striking colored pencil details, such as line impressions, add crisp contrast and draw the viewer closer, building visual interest.

Line Impressions

One very quick and effective way to create delicate linear textures is to create line impressions. A line impression is made by incising tiny grooves into the relatively soft drawing surface. These impressed strokes form valleys in the soft paper and layers of colored pencil simply skim over them, leaving them untouched, so that you have light, crisp, contrasting lines. Such impressions work beautifully for delicate light lines against a darker background, depicting woven or lacey textures, dandelion fuzz, angora, feathers, ribbed corduroy, light or white eyebrows and whiskers, basket fibers, even the delicate tracery of fish scales!

To create impressed lines, first prepare a basic line drawing and decide which areas will be incised to look like veins, whiskers, or other fine lines. Using a stylus, press heavily with a steady hand and draw the desired lines. (Many stylus sizes are offered, but usually the smaller and sharper the point, the better.) Stroke on more colored pencil layers and note that the impressed lines remain crisp and light, leaving a delicate contrast.

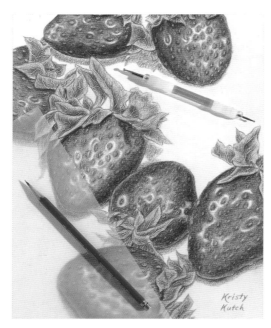

Sharp-edged incising tools, whether used through drafting vellum with a very hard (6H to 9H) pencil or directly with a stylus, create crisp line impressions.

A variation on this technique is to place heavy tracing paper or translucent drafting vellum directly over the prepared line drawing. (If necessary, lightly tape the overlay paper in place with removable cellophane tape.) With a *very* sharp 6H to 9H graphite pencil, draw the desired lines on the translucent overlay paper with heavy pressure. This method not only makes impressions on the underlying drawing surface, but creates graphite markings on the upper sheet which may be easier to see than stylus lines.

Sometimes an artist wishes to show impressed lines which are not white, or are not the underlying color of the drawing paper. To create impressed lines of a different color, first stroke one or more layers of pigment onto the drawing surface. This creates a base layer of a desired hue. Impress the lines over this base layer of color, following either of the procedures for incising. Finish by stroking on one or more layers of colored pencil pigment. The fine textures readily

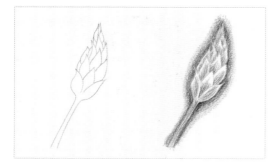

Line impression can be done with a stylus, first pressing hard and creating the textural lines, then going over them with color to show the effects. The second step of adding the color makes the impressions apparent.

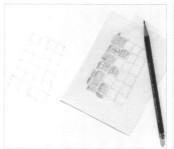

LEFT: A 9H pencil is used through a drafting vellum overlay sheet to create basket-weave striations in the paper.

RIGHT: Adding color over the basket-weave impressions accents the incised texture.

appear, showing the most recent layer of color before the impressions were made.

Reversing Impressed Lines

Everyone has had an unfortunate drawing experience caused by a slip of the hand. What can be done to repair a mistakenly impressed line? (Sometimes an accidental line impression can even be made by the artist's watch-band or bracelet resting heavily on the drawing paper.) One option is to use the fine point of a blending marker such as the Sanford Prismacolor Colorless Blender Marker, stroking the pigment from the neighboring area, and coaxing it into the impression.

Another solution is to sharpen a pencil of the repair color to a fine point, placing it very close to—but not quite touching—a warm lightbulb. After about five seconds, the waxy pencil point softens enough from the heat of the bulb to be stroked into the line impression, filling in the groove and nicely concealing the error.

Rescue an accidental line impression by sharpening the colored pencil to a fine point and warming it for a few seconds near a lightbulb. Then apply the repair color directly into the incised line.

The color hazel was used as a base color for the dune grasses, which were later incised, with other colors then added over the line impressions. Thus the hazel is the hue which peeks through the impressions.

Another method for accidental line impression damage control is to use the fine point of a liquid blender. To fill in the error, simply drag the desired color into the incised line.

For several years I have been reading about a sanded pastel paper from England called Fisher 400. Since it has recently become available in the United States, I was curious to try some to see how it would accept the pigment of soft, blendable Caran d'Ache Pablo pencils. I was especially interested in how the paper might work with heat blending a vivid blue summer sky.

1 On Fisher 400 sanded pastel paper, I lightly drew a horizon line slightly above the halfway point of the composition. (Fisher paper is very toothy, I learned to not be too worried about abrasiveness to the pencils. Sharpen, sharpen, sharpen!) I stroked gentian blue across the top of the sky, overlapping with bands of blue jeans, then bluish pale partially overlapping the bands of blue jeans. Finally, I graduated the blue sky down to a slim band of bluish pale, with white at the horizon line.

2 Using a heat gun, I warmed the sky, holding the gun about 1 inch above the surface and constantly moving it. Starting with the lightest bands of colors, I blended the sky with a stiff blending brush, a large stomp, and a Caran d'Ache Full Blender Bright blending rod. Using sideways back-and-forth strokes, I ran the blending tools parallel to the horizon. I kept adding gentian blue to the sky, then more white to the clouds. To create a super-white touch to the brightest areas of the clouds, I added very heavy touches of a Stabilo white Aquarellable pencil.

3 I stomp-blended the sky blues. I followed with a sketch of the dune. I erased the blended sky color from the crests of the dunes. On the left, I drew dune grasses, using strokes of olive black, and adding touches of dark carmine and khaki green. On the left distant dune, I drew olive black and dark carmine strokes, highlighting with light lemon yellow. I laid in shadowy aubergine mid-ground, since the grasses would be drawn upon those shadows. Blending the shadows with a stiff brush, I swept along the dune contours. The near foreground shadows remained unblended. I used Scotch Removable Tape to lift unwanted smudges.

4 I stomp-blended aubergine dune shadows, adding sharp dark aubergine strokes in the deep footprints. On the dune crest and along the tops of the footprints I added strokes of light lemon yellow and white. Beginning with the distant ridges, I drew sharp strokes for the dune grasses, repeating the grass colors, and adding white on the most sunlit grasses. Where they cast shadows on the sand, I drew light lines of aubergine, blending very slightly.

Fisher 400 Paper accepts pigment densely, but it tends to smudge easily. I immediately took this finished art outside and sprayed it with Lascaux fixative.

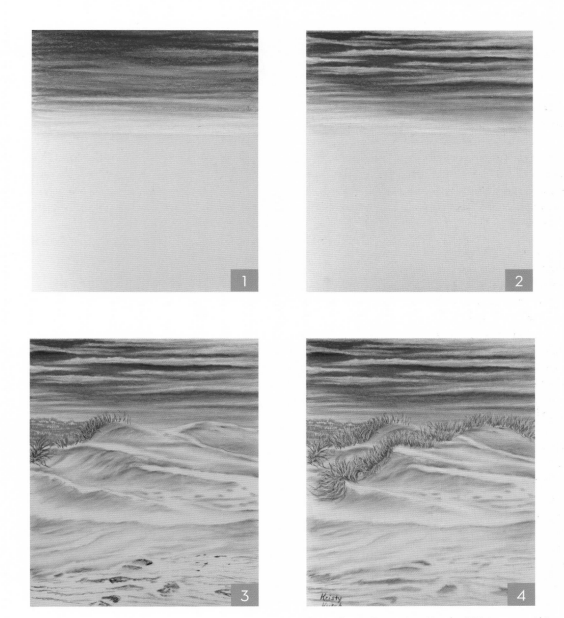

Dune Crest, Kristy Ann Kutch, CPSA, 2013, 9¹/₂" x 11⁵/₈", colored pencil on Fisher 400 sanded paper.

Creating Delicate Line Impressions

Revere is a new Italian paper from a fifteenth-century source: the same historic Italian mill which produced the paper for Napoleon and Josephine Bonaparte's wedding invitations. I decided that this soft, plush paper might be well-suited to the delicate tracery of line impressions. With stylus in hand, I set out to capture the many fine, delicate veins and striations of this elegant pink iris.

1 On Revere silk, I created an iris line drawing. Using a Caran d'Ache Pablo olive yellow (complement of pink), I rendered the shadowy areas of the petals. With Pablo purplish red (a complement of yellow-green), I indicated the shadowed areas on the stems, followed by a layer of khaki green. Applying purplish red and flame red at the base of the iris "beard," I then added short strokes of orangish yellow for the fuzzy strands. While experimenting, I discovered that a battery eraser was too aggressive for Revere silk. Low-tack frisket film or Scotch Removable Tape worked well for gentle lifting.

2 With a stylus and a firm hand, I incised fine lines where the hairy strands of the beard appear. Continuing with the impressions, I also incised in the furrows of the iris petals and the striations of the stem. I stroked khaki green over the stem, followed by olive black, purplish red, and periwinkle blue for the deeper, shadowy values of the stem. The line impressions showed up well on the stem. I added color to the smaller sections of petals: periwinkle, raspberry red, and purplish red in the shadows, with granite rose and salmon pink on the lighter areas.

3 I used salmon pink for the petals, saving the white of the paper for highlights. Needing vibrant shadow contrast, I added touches of periwinkle, followed by purplish red and ruby red over the periwinkle. I lifted fine lines on the beard with Scotch Removable Tape and a stylus. As reflected beard colors on the pink iris petals, I used touches of fast orange and apricot. For translucent areas on the petals, I lightly added dark green and khaki green, indicating the sheerness of the petals. I stroked dark green on the shadowed parts of the stem.

4 To create the background I prepared a cushioning layer of a thick section of newspaper underneath the art paper. Then I used small circular/oval overlapping purplish red strokes in the negative space. After one layer I decided to add a second application, again with overlapping oval strokes and the side of the pencil. Taking a handkerchief I gently blended the background and it easily smoothed out to a lovely, even layer. With a very sharp purplish red pencil and a few strokes of a very sharp carmine pencil, I emphasized the lines between petals and created crisp edges along the iris petals.

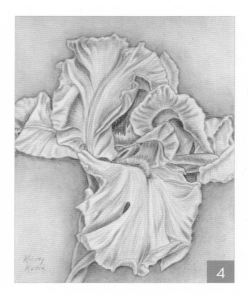

Pink Iris, Kristy Ann Kutch, CPSA, 2013, 9¹/₂" x 11⁷/₈",
colored pencil on Revere silk paper.

Frottage

Frottage is a method for creating texture that is similar in principle to making a leaf rubbing. Place the drawing paper directly over a heavily textured item like a grainy piece of wood, a metal screen, rough stone, or a lace doily. Using the side of the colored pencil and applying heavy hand pressure, stroke until the underlying texture becomes obvious. Frottage can be useful in creating a novel background, and it is most effective with lightweight papers.

Sgraffito

Sgraffito relies on first applying multiple very heavy layers of colored pencil. Using a sharp blade like a razor or X-Acto knife, very carefully scratch a fine line of pigment from the top layer, revealing the different pigment layer underneath. Take care to always have a sharp blade to make a clean, sharp line.

Mottling and Speckling

Mottled or speckled effects are quick and easy to render with a few common items. Take a length of masking tape or drafting tape and wad it lightly into a loose ball. Apply several layers of pigment to your paper, then lightly press the wad of tape onto the surface, lifting some of the color. Move the wad to a fresh area, press, and repeat the lifting process. This gives a randomly mottled effect which can be used to render backgrounds, earthy textures, or dappled sunlit greenery.

The kneaded eraser is useful for more than simply stroking away sketch lines. This inexpensive gray eraser can be firmly pressed onto layered colored pencil pigment, then lifted to create mottled textures. Once lifted, it pulls off a little of the top layer of pigment, leaving a hazy or dusky effect. Following the same procedure, reusable adhesive putty, often called poster putty or sticky tack, is also effective for creating speckled or dusky textures. Simply dab the putty on the area and lift to reveal a mottled effect, or use it to gradually remove any extra layers of pigment. Leaving no sticky residue, this putty is safe and

TOP, LEFT: This frottage was created by placing a lace doily underneath Terraskin paper, then rubbing across the paper surface with a broad Lyra Colorstripe pencil.

TOP, RIGHT: This driftwood's linear texture was achieved by scratching a very sharp blade through the heavy colored pencil layers.

BOTTOM, LEFT: A small wad of crumpled masking tape dabbed against heavy layers of colored pencil can give a mottled, earthy effect.

BOTTOM, RIGHT: Reusable adhesive is a helpful tool for creating mottled or hazy textures.

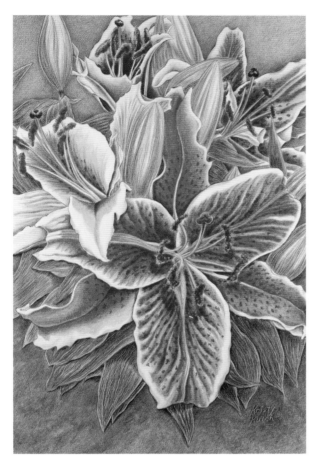

Asian Lilies, Kristy Ann Kutch, CPSA, 2007, 12" x 15", colored pencil on Fabriano Artistico 140-pound hot-press watercolor paper.

Besides being a great color-lifting tool, reusable adhesive is wonderful for creating a mottled effect. In *Asian Lilies*, the entire background was a safe solid green blend, but I decided to dab reusable adhesive on the lower part of the picture, breaking up the solid green. This dabbing picked up some pigment; then I added some touches of the rose hue found in the lilies, lending a nice color reflection.

gentle to use on colored pencil. (There is some variation among brands of reusable adhesive and kneaded erasers, some being stickier than others.)

Since the kneaded eraser and the reusable adhesive do pick up pigment, as expected, you'll need to freshen them; to do so, simply knead and pull the eraser or putty around to a clean spot. Keep them clean and away from dust and pencil shavings by wrapping them in aluminum foil or storing them in a small plastic case.

Airbrush artists frequently use a low-tack plastic masking film and colored pencil artists have also adopted it. Frisket film is lightweight, easy to cut, and features a layer of slightly adhesive clear film with a paper backing. Peeling back the protective paper layer, the artist places the sticky side of the frisket film directly on the layered colored pencil surface. The frisket film can be rubbed or drawn upon with a butter knife, stylus, or other blunt drawing tool. Once lifted and peeled back from the art surface, it reveals randomly textured or linear effects.

Frisket film, a favorite tool of airbrush artists, is excellent for gently lifting colored pencil layers, rendering interesting textures.

POSITIVELY BEAUTIFUL NEGATIVE SPACE

Sometimes we want to create a background without fussing. No one relishes drawing tiny details such as hundreds of twigs and leaves in the negative space of a floral image, for example. In terms of perspective, it is often not even appropriate to focus equally on the minute background details, as they need not and should not appear as precise and finely detailed as the subject.

The following are helpful considerations when creating speedy and attractive backgrounds. They can beautifully complete the composition without anxiety, and they often take only a matter of minutes to execute. Whether the pencil pigment is dry or wet, these methods offer some interesting and appealing options.

Less Can Be More

Sometimes the best solution for a background—whether the artist has anticipated it or not—is to simply *leave the art surface alone.* Think of scientific illustration and botanical art, where the main subject is depicted against a plain white background. Let the surface supply the negative space, with no added features, or, as in *Cherries, Berries, and Nectarine,* (right, top) just the barest hint of color behind the composition. If the subject is a still life, add some cast shadows to anchor the composition—or not, as in Karen Coleman's exquisite art, pictured on this spread.

Allowing the white paper or board to serve as background can lend a painting simplicity and elegance. Each of Coleman's paintings (bottom and opposite) offers so much in terms of subject matter, color variety, and brilliance, that they need no special background treatment. The white of the paper is quite enough and doesn't compete with the subject.

PREVIOUS PAGE:

TOP: *Cherries, Berries, and Nectarine*, Kristy Ann Kutch, CPSA, 2011, 14" x 11", colored pencil on vellum-finish Bristol board paper.

BOTTOM: *Fuzzywuzzy Airplant, Tillandsia pruinosa*; Karen Coleman, CPSA, 2008, 10" x 8", colored pencil on Stonehenge paper.

THIS PAGE:

TOP, LEFT: *Bloodroot, Sanguinaria Canadensis*; Karen Coleman, CPSA, 2010, 10" x 14", colored pencil on Grafix Dura-lar. Collection of Mark Symborski.

TOP, RIGHT: *Saucer Magnolia, Magnolia x soulangiana*; Karen Coleman, CPSA, 2009, 9" x 12", colored pencil and watercolor pencil on Ampersand Pastelbord.

BOTTOM, LEFT: *Eggplant*, Karen Coleman, CPSA, 2010, 9" x 12", colored pencil on Stonehenge paper.

BOTTOM, RIGHT: *Cecropia Moth*, Karen Coleman, CPSA, 2010, 8" x 10½", colored pencil on Grafix Dura-lar. Collection of Patricia Kernan.

Using a Toned Surface as Your Background

Many landscape and portrait artists—even courtroom sketch artists—begin with a colored surface of tinted pastel paper or toned drawing board. Not only does such a colored substrate save time, but it also pulls together a composition with a unifying, underlying hue. It lends a certain elegance and finish to even the sketchiest rendering, which might otherwise look incomplete on a simple white surface.

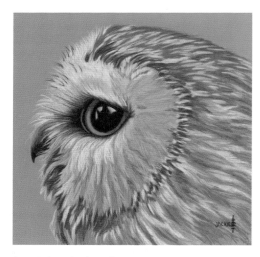

Saw-Whet Owl, Jackie Treat, 2012, 8" x 8", colored pencil on Art Spectrum Colourfix Suede.

Jackie Treat photographed Tiresias, a small northern saw-whet owl with impaired vision, at the Cascades Raptor Center in Eugene, Oregon. Jackie's choice of tan Colourfix Suede paper lent itself beautifully as a background and a base color—note especially the feathers around the eye—for the plumage of this protected owl.

When selecting a colored surface, it is important to consider the shade carefully, since dark colors might not be suitable for very light-colored subjects. (I learned this lesson the hard way when I chose a very dark green paper to portray a field of daffodils.) Although some artists manage to conquer black and effectively use very dark values of colored papers and board, the darker the substrate is, the more challenging it is to achieve light, luminous values. Very light colors tend to get lost against a dark surface. Thus, it is wise to select colored surfaces which are mid-value, not extremely dark.

Close-Cropped Composition

One method for handling negative space is to fill the composition completely to the brim so that there is very little area behind the subject. In *Regan's Rugosa Rose* (opposite), the entire paper is nearly filled by the oversized blossom. Note that there is very little of the violet background and the flower dominates. I created the background by placing several sections of newspaper underneath the drawing surface, then used light-touch overlapping circular and oval strokes, lending a very soft effect. The cushioning of the newspaper layers and the gentle touch of the overlapping strokes are essential for the soft background here.

Vignettes

A vignette adds a toned backdrop to a composition—an attractive surrounding halo of color. Sometimes it is so subtle that the viewer does not initially notice this extra enhancement, but it adds a finishing touch

behind the main subject. A vignette is often used by portrait artists, lending a soft aura of color around the head and shoulders of the subject. Yet another use of a vignette can be a subtle band of color around a still life or floral composition.

A dry, penciled vignette background is speedy and can be done with either traditional, non-watercolor pencil or the water-soluble type. This is a quick solution for enriching a background with a soft glow of color. The only items needed are a colored pencil, some type of grating screen or mesh to grate the pencil tip into a fine powder, and a blending tool like a soft cloth, foam pastel sponge, or tissue.

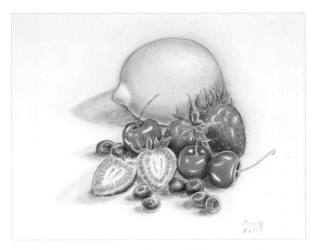

Kitchen Gems, Kristy Ann Kutch, CPSA, 2009, 14" x 11", colored pencil on Borden & Riley vellum-finish Bristol board paper. Collection of Keri and Daniel Kutch.

Kitchen Gems was inspired by a trip to the market and the bright summer sunshine streaming into our kitchen window in a Minnesota cabin. I was eager to capture the shimmer of the cherries, as well as try my hand at the surface of the lemon, which I first dimpled with a stylus. To give the simple subjects a subtle pop, I created very soft vignette of the palest blue.

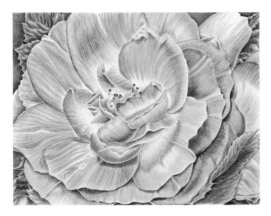

Regan's Rugosa Rose, Kristy Ann Kutch, CPSA, 2011, 20" x 16", colored pencil on Rising 4-ply museum board.

I used Rising 4-ply museum board to ensure that my line impressions appeared fine and delicate, and I was happy with the way the soft Caran d'Ache Pablo pencils took to the velvety, yet sturdy surface. This piece moved along so quickly—largely due to the accepting texture of the board—I was almost sorry when I finished!

Part One presented many possibilities, techniques, and tricks of the trade for traditional colored pencils. Rich and waxy, dense and buttery, they are amazing tools. We'll next explore the *other* colored pencil—the aquarelle, or water-soluble colored pencil—a surprising hybrid product which enables both drawing and fluid painting.

Letting the Toned Surface Do the Work for You

Michigan dune grass was a simple but elegant subject, something pleasing to the eye but not too daunting. It was easy to emphasize the lightest and darkest values on this shade of paper, since the surface itself provided a nice sandy mid-value. I used Caran d'Ache Pablo pencils, unless otherwise noted.

1 I sketched the dune grasses on Art Spectrum Colourfix Suede paper with a violet Sanford Col-Erase pencil. With a Caran d'Ache Pablo spring green pencil, I then added color to the blades of dune grass.

2 I stroked a sharp light lemon yellow pencil onto the lightest areas of grass blades, then I added olive on the darker regions. I used the blunt side of a periwinkle pencil to sketch some violet in the distance, adding perspective. I lightly sketched shadows of the grasses with periwinkle, using the blunt side of the pencil. With a Sofft tool sponge, I blended the periwinkle blue areas. Noting the occasional small holes in the sand and at the base of the dune grass clusters, I emphasized their shadows with periwinkle. I then added light lemon yellow on the highlighted ridges around these depressions.

3 Next I deepened the dark colors, enhancing the lightest values. I used a sharp olive black pencil to line the undersides of the blades, resharpening frequently. I then added light lemon and white to the highlighted areas on the grasses. In the sand holes, I emphasized the dark colors by adding a fine touch of violet, and light lemon yellow on the sunlit ridges. I used a soft cloth to blend the sand ridges. Finally, with a Tuscan red Sanford Verithin pencil, I edged the dark sides of the grass blades so that they would have a more three-dimensional appearance.

Michigan Dune Grass, Kristy Ann Kutch, CPSA, 2013, 9¹/₂" x 11⁷/₈", colored pencil on Colourfix Suede paper.

Creating a Graduated Vignette

A dry penciled vignette is very easy to render and saves time and fretting. When I use this technique, I select a colored pencil—or perhaps two or three pencils in different values of the same color—for the background. I always make sure to have a drawing pad or several sections of newspapers as padding for underneath the art surface, since such cushioning lends softness to the vignette.

1 I first placed padding underneath the drawing surface, cushioning with two or three sections of newspaper. Keeping the drawing paper on its pad also helps. Using the side of the permanent, non-watercolor pencil—in this case Caran d'Ache Pablo marine blue—I then drew oval or circular overlapping strokes. I worked from the main subject outward.

2 Concentrating the darkest marine blue value closest to the shell, I graduated the values, making them lighter as I moved away from the shell. The vignette need not cover the entire background and can gracefully fade out in value.

3 Where the transition between values seemed to be too abrupt, I used a tissue in circular motion to meld the colors so that they transitioned more gradually; a blending sponge also have worked. Underneath the shell, I added Caran d'Ache Pablo bistre in the darkest nooks of the shadowed area, transitioning to brown ochre, and then to golden ochre. I blended these with the fine point of a small blending stomp, since it could nicely reach tight little corners.

WATER-SOLUBLE COLORED PENCILS

6 WATER-SOLUBLE COLORED PENCILS AND COMPATIBLE SURFACES

AQUARELLE, WATER-SOLUBLE, WATERCOLOR: WHAT-ever term you use for this type of hybrid colored pencil, it is indeed a versatile drawing and painting medium. What exactly is a watercolor pencil? Is it colored pencil or is it watercolor? With a composition of finely ground pigment, binder, and filler, the pencil is formed into a core or rod. At some point it is treated to include water-soluble wax and then enclosed (or not) in wood. With a sharpened point, it is ready to stroke and layer onto an art surface, appearing dry and rather granular. Once the drawn layer is activated with a damp brush, the color becomes liquefied, creating a smooth, fluid wash effect.

Not only are watercolor pencils nontoxic, they are neat and portable, offering the artist the flexibility to move from dry to wet with a damp brush stroke. What's more, they combine rich color with the precise, pointed control of a pencil. Plein air artists find them ideal for drawing in journals, sketching spontaneously on location, then later washing with a brush or even expanding the images into larger paintings as desired.

New lines of aquarelle drawing products are steadily increasing and curious art consumers are enthusiastically adopting them. Still, many drawing artists and watercolor artists who own watercolor pencils are often at a loss about how to use them. This chapter and the one that follows should give you the know-how to use water-soluble colored pencils in exciting, creative ways.

PREVIOUS PAGE: *Tulip Cascade*, Kristy Ann Kutch, CPSA, 2012, 20" x 15", colored pencil and watercolor pencil on Crescent hot-press watercolor board.

I started *Tulip Cascade* blooms with a water-soluble pine green complementary underpainting. After it dried, I applied and washed watercolor pencils for rosy coral hues. I then underpainted a magenta wash and let it dry before applying the aquarelle greens of the leaves. For rich intensity I added non-watercolor pencils over the aquarelle layers. I used blending pencil for shimmer, followed by layers of waxy permanent pencil.

NEXT PAGE: *Dahlia Dazzle*, Kristy Ann Kutch, CPSA, 2013, 12" x 15", watercolor pencil on Art Spectrum Colourfix Suede paper.

Eager to experiment with permanent, staining water-soluble pencils on Colourfix Suede paper, I was thrilled with the way Suede accepted the rich aquarelle pigment. The combination of the subtly sanded paper and the heavily pigmented pencils enabled me to create a vibrant image of Oregon dahlias that truly popped.

AROUND THE WORLD WITH AQUARELLES

Excellent artist-grade watercolor pencils originate from many different countries. Whether from makers predating World War II or relatively new brands, there are many innovative aquarelles varying in pigmentation and permanence, composition and form. From the United States, Western Europe, or Asia, there is worldwide appeal in this versatile hybrid art medium.

Rich in Color and in History

Lyra Rembrandt Aquarell Colored Pencils are a German product from the small, but very high-quality Lyra Company—which is credited with making the first aquarelles—now affiliated with FILA (Fabrica Italiana Lapis e Affini) of Italy. The 72 hues correspond to the Lyra Rembrandt Polycolor traditional colored pencils and represent a beautiful, well-balanced range of colors, including excellent flesh tones. Lyra's wine red is highly lightfast and is very useful in landscape art as a complementary color for underpainting greenery. Lyra Rembrandt Aquarell Pencils are a little too large to fit into most electric and battery-type pencil sharpeners, but they are worth the effort to hand sharpen.

Caran d'Ache Supracolors is another long-respected brand of watercolor pencils, available in 120 colors. Made in Switzerland, Supracolors lend an exceptionally soft sensation, similar to the feeling of a 6B pencil. The color range of the collection is extensive, with an emphasis on colors and not too many grays.

The collection of 72 Derwent Studio Watercolour Pencils is also one of the earliest types of water-soluble colored pencils. Made in Great Britain, this set offers a beautifully balanced selection of hues and the pencils easily fit into an electric sharpener. Derwent Watercolour Pencils were recently improved and now have a softer feel. Open-stock pencils are available, too, for replacing favorite colors.

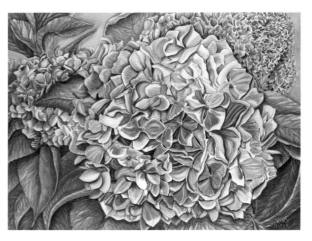

Hydrangea Blues, Kristy Ann Kutch, CPSA, 2011, 20" x 16", watercolor pencil and watercolor wax pastel on Aquabord.

I planned *Hydrangea Blues* for a watercolor pencil demonstration on Aquabord at an art-supply trade show. I drew the blossoms in a variety of blues that I knew would attract onlookers, and I created the leaves by incising veins while the Aquabord was wet—digging right into the soft, clay-based surface. (For more about Aquabord, see page 97.) For a patch of sky in the distance, I made a customized palette of a NeoArt wax pastel (see Chapter 9), scribbling it onto a small scrap of Aquabord and wetting it to make a convenient puddle of wash, ready for painting.

From Germany come the exceptional Faber-Castell Albrecht Dürer Watercolor Pencils. These highly pigmented watercolor pencils are available in 120 hues, including metallic, which drip with color. Leaving no granular traces, they dissolve completely into smooth washes. The only drawback is that, like Lyra Rembrandts, they require a hand sharpener.

High Quality and Convenient

Sanford Prismacolor Watercolor Pencils are available in 36 colors. These aquarelle pencils are easily found in open stock in both art-supply stores and craft shops, which is an advantage when shopping for replacements. One of the colors is a non-photo blue, which is lovely to behold but which "ghosts out" when photographed or copied with a color photocopier. Mark that pencil well and use it for preliminary line drawings. Prismacolor Watercolor Pencils sharpen in any sharpener and dissolve purely into lovely washes, especially poppy red and crimson red.

A new addition to the world of watercolor pencils is the Bruynzeel Design Aquarelle collection of 48 colors. With excellent construction and cores which are securely glued into the wooden casings, Bruynzeel Design pencils are durable and less prone to breakage, and thus, loss of the pencil core. Each pencil is encased in light cedar, which is superior to red cedar for smooth and even sharpening. The colors are vivid and dissolve well with a few swishes of a damp brush.

Lusciously Layerable

The British company Derwent has launched the Graphitint line, an array of subtly colored and naturally muted water-soluble graphite pencils.

Permanently staining watercolor pencils, another recent addition, permit layering and glazing without disturbing the underlying layers. Among these, Derwent sells vibrant Inktense Pencils and Inktense Blocks, which are highly pigmented, ink-type pencils and their corresponding chunky rods. The Swiss company Caran d'Ache markets concentrated Museum Aquarelle pencils, which are also very staining and packed with pigment. It is no wonder that colored pencil artists and watercolorists alike are intrigued by such new products.

Quality water-soluble pencils span the range of prices, but even the high-end brands can be quite

Prominent artist-grade water-soluble pencils, from top to bottom: Sanford Prismacolor Watercolor Pencils, Lyra Rembrandt Aquarelle Pencils, Faber-Castell Albrecht Dürer Pencils, Derwent Watercolour Pencils, Derwent Graphitint Pencils, Cretacolor Marino Pencils, Cretacolor Aquamonoliths, Caran d'Ache Supracolor Pencils, and Bruynzeel Design Aquarelle Pencils.

affordable, especially if you scout the sales or build a set from open stock. I started my own colored pencil collection with a very small set and then bought pencils three or four at a time, as I needed and could afford them.

Woodless, Lightfast, and Graphite-Colored Combinations

Several lines of water-soluble pencils offer traits which make them unique. Cretacolor Aquamonoliths from Austria have a niche in that they are woodless rods of water-soluble color, easily sharpened like pencils, yet large enough to create wide swaths of color. Each Aquamonolith is a heavy, very dense product, composed of organic and inorganic pigments, with the finest Kaolin (china clay) base and different types of waxes and oils as binding agents. The Aquamonolith is pure product, with no wood casing—even shavings can be dissolved and used. Cretacolor Aquamonoliths are offered in 72 colors, quickly cover large areas with rich, soft strokes, and can be applied as dry color or washed with a damp brush.

Cretacolor also markets a collection touted as exclusively lightfast watercolor pencils. Cretacolor Marino Pencils come in 36 colors. The Marino palette includes magenta, violet, and a pink hue, cyclamen. This is noteworthy because colors in the violet and pink families are often more fugitive, that is, delicate with regard to lightfastness.

The Derwent Graphitint Pencil is a unique product featuring water-soluble graphite pencil combined with color. Available in 24 muted shades, Graphitint

hues look very natural in landscape art. Drawn on dry, they look muted, but the colors become more vibrant when dissolved with the stroke of a damp brush. Similar to Graphitints, Derwent has also launched XL Graphite, water-soluble chunky blocks in 6 subtle colors.

Poppy Unfurled, Kristy Ann Kutch, CPSA, 2004, 9" x 9", watercolor pencil on Fabriano Artistico 140-pound hot-press watercolor paper.

Using Cretacolors, with their excellent palette of oranges, reds, and greens, made this small painting appealing, easy, and fun. Fabriano Artistico hot-press watercolor paper was an ideal surface for this application because it is smooth and flawless.

Permanent Aquarelles

Two fairly new brands of water-soluble pencils occupy a special niche for permanence of aqueous color. The staining quality of Caran d'Ache Museums and Derwent Inktense Pencils and Blocks is ideal for the artist who wants to first create an underpainting of a complementary color. Like other watercolor pencils, they are applied dry, initially appearing textured and granular. Once dissolved and then allowed to dry, however, they become permanent. Glazing (adding successive layers of color) becomes an easy process. With such permanent watercolor pencils there is less danger of "creating mud," or accidentally lifting the underlying layers. This allows a lovely, clean buildup of glazes.

Caran d'Ache's very saturated watercolor pencil, the new Museum Aquarelle, was initially available in a basic set of colors, but is now also offered in the Marine Assortment and the Landscape Assortment of hues. Extremely lightfast, Museum is a permanently staining, concentrated, easily dissolved colored pencil.

WATER-SOLUBLE PENCIL COLLECTIONS AND TRAITS

PRODUCT NAME	NUMBER OF SHADES	PRICE LEVEL	KEY CHARACTERISTICS
Bruynzeel Design Aquarelle	48	Budget-friendly	Excellent grooved core construction, vivid reds and oranges, dissolve well; set includes brush
Caran d'Ache Supracolor	120	High-end	Soft laydown which feels like 6B graphite pencil
Cretacolor Aquamonoliths	72	High-end	Woodless, densely heavy rod which is all product
Cretacolor Marino	36	Mid-range	Lightfast collection, not widely distributed, no open stock
Derwent Graphitint	24	High-end	Graphite mixed with colors
Derwent Watercolour	72	Mid-range	Long-established pencil line, one of the oldest
Faber-Castell Albrecht Dürer	120	High-end	Rich pigmentation, dissolves readily
Lyra Rembrandt Aquarell	72	Mid-range	Great color selection, wonderful greens
Sanford Prismacolor Watercolor	36	Budget-friendly	Limited palette, but widely found in open stock

The cores are loaded with pigment and render intense, flowing color with just a few strokes and the sweep of a damp brush. Once activated with water and dried, the Museum Aquarelle wash is designed to be permanent. Museums especially appeal to the discriminating artist who wants a top-notch aquarelle pencil. Derwent Inktense Pencils and Inktense Blocks are described by the company as water-soluble ink products, being more staining and permanent in nature than the original type of watercolor pencils. The 72 colored pencils, including an India Ink–like outliner pencil, are highly pigmented, and the hues are brilliant and saturated, especially after wetting. The palette of colors is stunning, with a wide range of vivid reds, oranges, yellows, greens, blues, and violets.

The 24 colors of chunky, woodless Inktense Blocks are all product (with no wood casing) and correspond to the hues of the same names found in the Inktense Pencil collection. Offering the option of easily sweeping

Face to Face, Karen Coleman, CPSA, 2008, 7" x 5", watercolor pencil and ink pencil on Ampersand Pastelbord.

Karen used a combination of Derwent Watercolour Pencils and ultra-vivid Inktense pencils in this painting. The Pastelbord, with its abrasive marble-dust coating, grabbed the pigment, yielding rich color when washed. This up-close and personal pansy reflects Karen's love of nature.

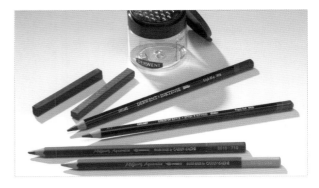

Caran d'Ache Museum and Derwent Inktense Pencils and Blocks are highly staining and more permanent. The Grate 'n Shake container allows the artist to grate an Inktense Block, with the pigment falling into the container of water, thus dissolving into a vivid wash which can be painted directly with a brush.

DUST OFF THOSE PENCILS!

Watercolor pencils are meant to produce pure, smooth washes. I had the unhappy accident of a wash that granulated because I forgot to clean the sawdust off my newly sharpened watercolor pencils, resulting in granular specks in the wash. I recommend the extra measure of cleaning pencils with a scrap of cloth, not tissue; cloth is less likely to introduce unwelcome little specks.

on large areas of permanent watercolor, Blocks deliver great intensity very quickly. Blocks can also be grated into a Derwent Grate 'n Shake container with water to quickly create a liquid wash. Both Inktense products, pencils and blocks, are also available in open stock. This is essential to the artist who has favorite colors that may need replenishing.

SURFACES FOR WATER-SOLUBLE PENCILS

Colored pencil artists are often surprised to learn that such a wide variety of grounds can accommodate aquarelle pencils or a combination of colored pencil types, including watercolor papers and boards, pastel papers, and multiple-media products.

Watercolor Papers

As one might expect, quality watercolor papers such as Arches, Cartiera Magnani, Fabriano Artistico, Strathmore Aquarius and Imperial papers, and Waterford Saunders accept water-soluble pencils beautifully. These papers have their own luscious feel and distinct qualities. Boasting a long and respected history, some of the paper mills which produce them have been in operation for hundreds of years.

How does one navigate the world of watercolor papers? First, select a paper which is acid-free and pure, with no components like lignin to cause discoloration and degradation of the finished art. Watercolor papers have gone through the sizing process, which

Plumeria, Kristy Ann Kutch, CPSA, 2006, 10" x 8", watercolor pencil on Fabriano Artistico 140-pound hot-press watercolor paper.

This painting of a West Indies flower, started as a demonstration piece, challenged me to emphasize the value shifts between the white plumeria blossoms and the very dark violet background. Watercolor pencil, layered heavily and dissolved, provided the dramatic negative space. The subtlest of violet washes added dimension to the pure white flowers, with no use of black or gray in the entire painting.

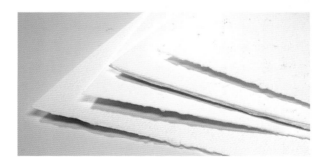

Watercolor papers come in a variety of textures. From left: rough, cold press, soft press, and hot press.

means that they have been treated with substances such as animal glue, synthetic materials, or starch to keep them from absorbing the watercolor pigment too quickly, like a blotter would. Such sizing lends strength to the paper and gives ample time to apply and move the wash. Fine papers are made from cotton, linen, rice, bamboo, or blends of materials. Watercolor paper is available in sheets, pads, or as blocks (which are sealed on all four sides to keep the damp paper taut.)

Material

Cotton is greatly favored among artists seeking the ideal substrate, since the cotton fibers are naturally longer, making a paper sheet which not only feels lovely to the touch but is stronger and more durable. Cotton papers also hold up well to handling, lifting, and—if the paper is heavy enough—even scrubbing and rinsing. Being a natural fiber, cotton is also a renewable material, and has been respected for many generations as an excellent aquarelle surface.

Weight

Watercolor papers have classifications which may at first seem puzzling, but can be easily interpreted. Weight refers to how much a ream—500 sheets—of full-size, 22- by 30-inch paper weighs. Usually, 140-pound paper is fine for watercolor pencil applications, but the artist using heavier washes may opt to choose the very hefty 300-pound sheet instead. (Strathmore Aquarius, made of a cotton and synthetic blend, is an exception to this rule of thumb since it is a lightweight paper which resists buckling.)

Finish

Watercolor papers and boards have various finishes, too, with the tooth ranging from highly textured rough to the smoothest hot press. As expected, rough finish watercolor paper is very toothy, with a visibly textured surface. Cold-press paper is of an intermediate finish, with slight texture. One company, Fabriano, offers a unique soft-press paper, which is smoother

TOP, LEFT: Watercolor pigment applied and dissolved on rough paper leaves tiny specks of white and holes in the wash. This can be very useful for depicting foamy ocean scenes.

TOP, RIGHT: Cold-press watercolor paper leaves some hint of texture and is a favorite intermediate surface.

BOTTOM, LEFT: The soft-press surface is only available as a Fabriano paper and is a little smoother than cold-press paper.

BOTTOM, RIGHT: Hot-press paper dissolves into a very smooth wash, with barely any tooth of the paper evident.

than cold-press but which still offers a subtle tooth. Smoothest of all the watercolor papers is hot-press paper, with the least visibly textured finish. Allowing for precise, crisp strokes without feathering, hot-press paper ideally accommodates meticulous detail for both wet and dry colored pencil types.

Multipurpose Surfaces

Consider, too, trying the many other materials that are usually marketed in relation to other media. Many of these are also well-suited as substrates for water-soluble pencils. Strathmore offers Illustration Board for Wet Media and Mixed Media Paper, versatile surfaces that accept watercolor pencil and colored pencil smoothly. Dry watercolor pencil pigment does not dissolve as readily on Mixed Media Paper or Board, which

may be preferable for portraying subjects featuring strong linear traits. Illustration Board for Wet Media is especially sturdy and non-buckling, much like hot-press watercolor board; each sheet comes with its own protective acetate slipcover, so it travels well in an artist's portfolio.

Sanded Pastel Surfaces

As I mentioned in Part One, pastel surfaces are not just for pastels! Using watercolor pencils on these gritty, toothy surfaces truly intensifies the brilliance of

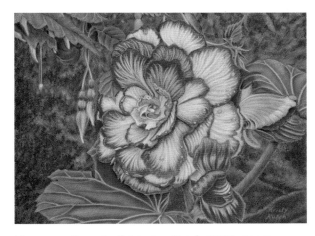

Vancouver Begonia, Kristy Ann Kutch, CPSA, 2007, 15" x 12", colored pencil and watercolor pencil on Schmincke Sansfix pastel paper. Collection of Elisabeth and Robert Lasater.

Although this painting features a combination of watercolor and traditional colored pencils, it was the sprayed soft-focus background which especially challenged me. The gritty Sansfix paper—new to me at the time—accepted the watercolor pencil pigment and the spray mist very well.

LEFT: Strathmore Illustration Board for Wet Media is a multiple-medium board which allows watercolor pencil pigment to dissolve quickly into smooth washes.

RIGHT: Another new multiple-medium board is Strathmore Mixed Media Board, the heavier counterpart to 500 Series Mixed Media Paper.

the pencils, allowing maximum saturation. Textured papers and boards have so much grit that more of the watercolor pencil pigment clings to the fine bumps on the surface. Thus, when the drawn area has been wetted, the dense color virtually explodes!

Pastel papers and art boards that accept watercolor pencil (and traditional colored pencil) beautifully include Art Spectrum Colourfix Pastel Paper and Plein Air Board, Art Spectrum Suede Paper, Canson Touch Paper and Touch Board, Ampersand Pastelbord, and Wallis Sanded Pastel Paper. With the exception of Wallis, I describe each of these in *Sanded Pastel Surfaces*, page 30, so I will simply touch on those with specific aquarelle-related characteristics here.

Wallis Sanded Pastel Paper is a very gritty, toothy surface, developed by the American artist Kitty Wallis. The quite durable Wallis paper can be repeatedly

wetted and scrubbed, with no damage to the tooth. The paper is advertised as able to accept at least twenty-five layers of pastel, so its capacity for colored pencil pigment is also great. Wallis paper is available in white and a tan color, Belgian mist; whether the artist

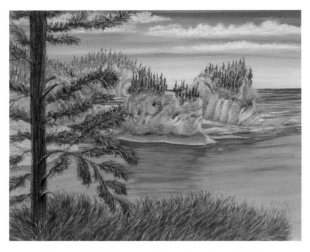

Cape Flattery, Washington; Kristy Ann Kutch, CPSA, 2013, 15" x 12", watercolor pencil and colored pencil on Colourfix sanded plein air board.

The Cape Flattery hiking trail is on the Makah Nation tribal land in Washington State. With stunning views of the Pacific Ocean, sea stacks, and caves, I enjoyed the awesome feeling of being at the northwesternmost point in the Lower Forty-Eight. Located in Olympic National Park, the trail is part of the dense rain forest and drips with moss. I depicted velvety green moss on the trees by lightly wetting the trunk and branches with clear water, then grating Museum Aquarelle light olive green and bright green pencils through a mesh screen directly over the damp areas.

Textured pastel surfaces are also excellent grounds for watercolor pencil. From left to right (grittiest to smoothest): Wallis Sanded Pastel Paper, Art Spectrum Colourfix Plein Air Board, Canson Mi-Teintes Touch Board, Ampersand Pastelbord, and Art Spectrum Colourfix Suede.

chooses professional-grade or museum-grade paper, the paper is highly archival.

Australian Art Spectrum Colourfix Paper and Plein Air Board also accept watercolor pencil beautifully. Note that original Colourfix paper and Plein Air Board require a longer drying period, beneficial for experimenting with wet-into-wet techniques.

Art Spectrum Colourfix Suede has a velvety surface which accepts watercolor pencil in either its dry or wet state, but it is better suited for small areas of watercolor pencil.

Aquabord

Aquabord by Ampersand Art was formerly known as Claybord Textured. Rebranded to a more recognizable name, Aquabord is a non-paper surface for watermedia and has unique characteristics. Because it is a specially prepared surface mounted on aspen hardboard (*not* Masonite brand), it does not need to be stretched and stapled to a support as watercolor paper sometimes does. Since the panel is so sturdy, it does not buckle and can even be taken as it is for plein air art sessions, with no drawing board required. Aquabord is ideal for traveling with one's art, since it is quite portable, durable, and can be neither wrinkled nor ripped.

This surface has to be seen to be appreciated. Made of kaolin clay layered onto hardboard, Aquabord features tiny bumps and projections. The manufacturer likens this to that of cold-pressed watercolor paper. Fine-gauge 400-grit sandpaper can be used to smooth the surface if it is too textured for your taste. (Dust the

Aquabord well after sanding.) Watercolor pencil pigment clings to these small, granular projections on the Aquabord surface, causing a greater concentration of color to adhere to the surface; once the pigment is dissolved, the tiny bumps almost disappear, giving a surprisingly smooth wash. The transformation from dry water-soluble pencil pigment to its dissolved state is dramatic and stunning.

Oregon Dahlia, Kristy Ann Kutch, CPSA, 2013, 5" x 7", watercolor pencil on Aquabord.

Watercolor pencil on Ampersand Aquabord transforms instantly with the sweep of a damp brush from dry, granular texture to a fluid wash.

SETTING YOURSELF UP FOR SUCCESS WITH AQUABORD

Ampersand Art inserts a notice to Aquabord users to first "flush out" the panel with a large wet flat watercolor brush. This process—essentially washing the board—releases trapped air, preparing it for watercolor washes. Sometimes I'll speed the process by using a hair dryer on the damp Aquabord. I have noticed that if I do not flush out the panel first, tiny bubbles appear and affect the smoothness of the wash.

Creating Texture on Aquabord

Textures on Aquabord can be fascinating and are easy to achieve. Ampersand markets a small wire brush which scratches the dry surface with tiny highlights, rendering hair, whiskers, and other wisps beautifully. The Ampersand line tool creates fine cross-hatching. Wet Aquabord can be incised with scratching tools such as the Ampersand scratch knife, a wax-carver, nut pick, stylus point, tiny crochet hook, or metal dental tool. Allow the surface to dry and brush away the tiny clay crumbs, leaving delicate white lines. If desired, add colored accents in the white lines with a tiny, precise brush such as a reservoir liner brush. Such incising is even a dramatic way to sign the finished Aquabord painting.

Aquabord lends itself well to a variety of incising tools (from left to right): nut pick, Ampersand line tool, Ampersand scratch knife, Ampersand wire brush, stylus, oil-free steel wool.

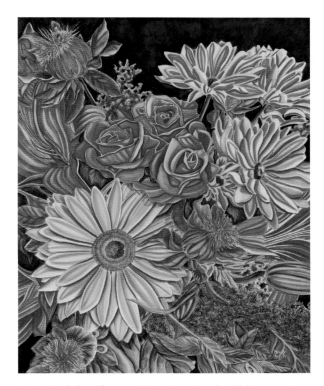

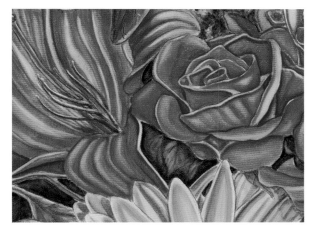

I created the textures at the center of the large daisy by digging at the damp Aquabord surface with a stylus.

Jan's Birthday Blooms, Kristy Ann Kutch, CPSA, 2008, 16" x 20", watercolor pencil on Aquabord. Collection of Jan and Rod Hoeppner.

This painting is my first large piece of art done with Inktense water-soluble pencils. I chose Aquabord as my surface because I felt that the grittiness of the board would cause the pencil pigment to cling to it with maximum intensity. Once an area was washed with a damp brush, the colors dissolved completely and brilliantly. Experimenting with tools, I used Ampersand's wire brush and a nut pick to carve textured features out of the damp clay-based surface.

I created the tassle-like textures in the orange flowers by using an Ampersand wire brush on that part of the surface, which I kept dry.

7 BRUSHES FOR WATER-SOLUBLE DRAWING PRODUCTS

skies and lovely, seamless graduated washes. Round brushes, especially those with good snap and fine points, cover a lot of territory. Depending on its size, a round brush can flawlessly sweep in a large area or deliver color to even the finest feature. Add to these the specialty and novelty brushes (like riggers and fan brushes), each with its own traits and functions, and—once again—the potential of watercolor pencil is amazing.

I USED TO BE FAMILIAR WITH JUST A FEW TYPES OF brushes, unaware of how easily the right brush can do its magic with watercolor pencil pigment. Since becoming better acquainted with aquarelles I have come to appreciate how valuable the right tool is for the task. Selecting the right brush for a water-soluble drawing—developing it into an actual aquarelle painting—can mean the difference between satisfaction and sheer frustration.

Brushes range from fine and wispy to large and full-bodied and are usually made from animal hairs, synthetic fibers, or a combination of both. Each type of brush has characteristics that make it a suitable tool for a specific effect. Flat brushes—with their broad applications—render smooth

Nevis Hibiscus, Kristy Ann Kutch, CPSA, 2008, 9" x 12", watercolor pencil on Aquabord. Collection of Debbie Remmel.

Growing on the West Indies island of Nevis, this radiant hibiscus was well-suited to the glazing potential of Aquabord. With a soft, round, size 12 brush and a puddle of liquefied watercolor pencil pigment, I gradually built up layer after layer of brilliant red.

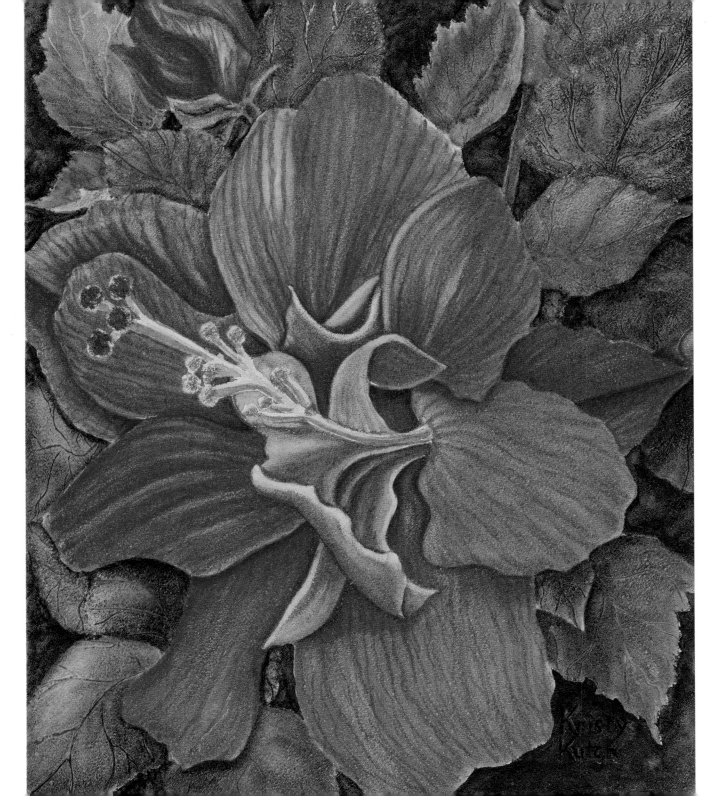

A BEVY OF BRUSH CHOICES

Although a standard round size 6 brush with good snap (that is, one that retains its shape) enables precision brushwork and is ideal for fruits, petals, leaves, and other small objects, there are other brushes of various shapes and sizes which can be valuable additions to the watercolor pencil artist's collection. Like a chef's many kitchen utensils, the aquarelle artist, too, has many tools and options for effectively developing a dry water-soluble pencil drawing into a fluid-looking painting.

Round brushes, as already mentioned, are suited for painting features like petals and leaves. They come in a variety of sizes; the smaller brushes work well for small items and larger ones are ideal for smoothly painting larger areas. A small brush offers precision but a large brush gives smooth, seamless, fluid results. A Kolinsky brush, made from Russian sable, is a high-end round brush that is a worthwhile investment.

Rigger brushes are round, but they are very long and wispy, ideal for painting dune grasses and reeds. The reservoir liner brushes I mention in this chapter are also well-suited to painting grasses.

A 1- to 2-inches wide flat brush is excellent for toning a paper or board to a desired color. It is also ideal for creating a pure, solid background such as a clear sky. Simply apply the watercolor pencil or water-soluble wax pastel pigment (dry) to the heavy paper or board. Wet the wide, flat brush and dab it off once or twice on a roll of toilet tissue to wick off the excess water. Then stroke the damp brush over the penciled area to dissolve the pigment. If liquid pools at the edge of the paper or board, lightly wick away—do not blot—the excess liquid with a paper towel. Allow the art surface to dry thoroughly before drawing or applying any other layers.

LEFT: A round brush is a versatile tool capable of rendering a wide range of strokes, creating even fine tendrils and stems.

RIGHT: Flat brushes are excellent for blending bands of smooth color and for creating graduated washes.

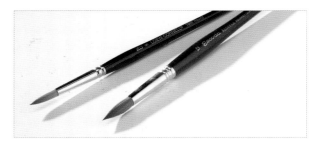

A brush with good snap, or precision, is essential. Note the fine point for use in tight spaces.

An angle shader brush looks like a flat brush, except its edge is angled, not squared and shaped to a 90-degree angle. The angle shader actually has a triple function: 1) It is well-suited for seamless, smooth blending of colors and easy maneuvering into nooks and around curves; 2) it is great for rendering vignette backgrounds and other negative spaces; 3) in case of an overrun error, a quick touch of a thirsty angle shader can lift, wick away, and correct the mistake.

Thirsty is a state of wetness, not a style of brush. It refers to a slightly damp angle shader brush, with most moisture wicked away, and it's easy to create. Simply wet the brush and drag it several times across a paper towel or dry cloth. There should be some slight moisture. Consider a slightly wet squeegee used for cleaning windows: the principle of lifting moisture is similar. The thirsty angle shader is also ideal for creating dimension and lifting highlights.

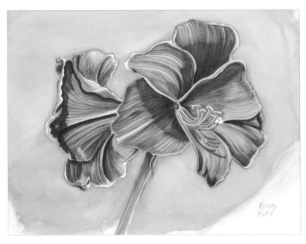

Amaryllis Duet, Kristy Ann Kutch, CPSA, 2012, 16½" x 13½", water-soluble wax pastel and watercolor pencil on Strathmore Illustration Board for Wet Media.

Seamlessly rendering the large sky behind the amaryllis blossoms was my first challenge. Using a size 20 round brush with a surprisingly fine tip, I quickly painted from a large puddle of dissolved pigment, working my way around the negative space. Once that was dry, I moved on to the flowers, switching to a size 10 round for the petals and a size 2 Cheap Joe's Lizard Lick brush for the finest stamens and the edging.

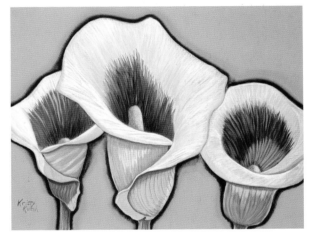

Calla Trio, Kristy Ann Kutch, CPSA, 2011, 16" x 12", watercolor pencil on Colourfix plein air board.

I edged in a vignette-style background around the lilies using the side of an angle shader brush with dissolved watercolor pigment. A dagger striper brush would have worked fine, too. (For more on water-soluble pencil vignettes, see page 79.)

In *Butchart Gardens Rose*, I used a thirsty angle shader brush to lift out shapes in the green background to suggest leaves. Angle shader brushes range in size from $1/8$- to 1-inch wide and are wonderful additions to the artist's cache of supplies.

The dagger striper brush resembles an angle shader brush, except that its edge is gently curved and tapered, not sharply angled. It has the capacity to maneuver around curves easily, rendering ribbon-like strokes with ease. The dagger striper can be as small as $1/8$-inch wide, giving precision with its sharp point. (It is also used by automobile detail artists for painting pinstripes.) The floral artist treasures this brush for

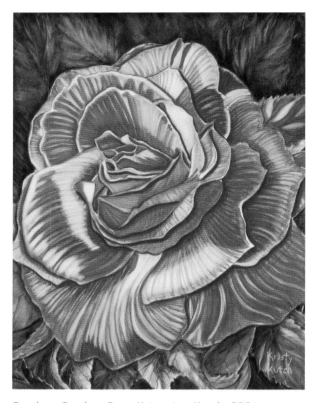

Butchart Gardens Rose, Kristy Ann Kutch, CPSA, 2008, 9" x 12", watercolor pencil on Aquabord. Collection of Col-Art Americas.

By looking up close at the detail of the dark green background, you can see how a thirsty angle shader brush lifts shapes. It takes a little practice to lift out the leafy areas.

smoothly painting tightly curved areas, such as the inner petals of a rose.

The reservoir liner brush is excellent for painting fine, precise lines. In spite of its shaggy, wild-haired look when it is dry, the brush, when wet, lends a fine, controlled line, with just the precision that I like so much. Once that wild hair has been dipped in liquid, the reservoir liner brush tapers to the finest point and holds a surprising amount of water. One brand is the Escoda Reservoir Liner Series 1310, available in sizes 2–16; another is Cheap Joe's Lizard Lick brushes in sizes 2–8. The belly (body) of the brush is plump and full, with a surprising fluid capacity, but the sable tip is extremely fine. This combination allows the artist to paint crisp edges without needing to reload the brush frequently with pigment. The size 2 model is an excellent brush for adding the artist's signature to a finished piece, too.

LEFT: Dagger striper brushes are ideal for softly moving around curves and into tight corners. They are very helpful tools for painting rose petals, with their characteristic curves and swirls.

RIGHT: A reservoir liner, in this case a Cheap Joe's size 2 Lizard Lick brush, is a must-have for creating delicate lines and fine edges. This tiny brush with a big "belly" holds an amazing amount of fluid.

SELF-CONTAINED WATER BRUSHES ON THE GO

When I am out drawing with water-soluble pencils and I need a damp brush, I use Aquaflo travel brushes. Available in round and flat sizes, the Aquaflo has a built-in reservoir so that it carries its own water. By squeezing its barrel, I can even self-rinse the brush between colors. The reservoir cartridge can be refilled as needed from a bottle of water and then capped, awaiting the next drawing and painting session.

A RESERVOIR BRUSH CARRIES ITS OWN WATER SUPPLY AND IS CONVENIENT FOR ART TRAVELS.

The scrubber brush with its abrasive, stiff bristles, is a workhorse for lifting pigment. Because the bristles are so sturdy, use scrubbers with caution on lighter-weight papers. They work very effectively on Aquabord, lifting pigment back to a very light value, often even to the original white of the board.

The Funny Brush is a unique, patented product with rubbery bristles. Available in three sizes, Funny Brushes work exceptionally well for loosely creating shrubbery and trees. Stippling and linear stroking also can be done with these brushes. Cleanup is easy with mild soap and running water. Funny Brushes are very durable, lasting for decades.

Scrubber brushes have stiff bristles to scrub out pigment from a damp surface. Note the difference between the tops of the slabs of these rocky ledges: the right ledge has been scrubbed.

Funny Brushes are excellent for stippling the foliage of trees, bushes, and even backgrounds.

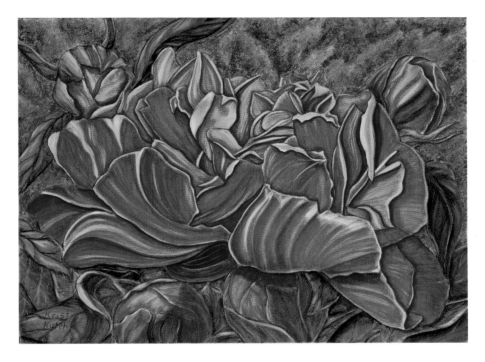

Peony Power, Kristy Ann Kutch, CPSA, 2009, 16" x 12", watercolor pencil and aquarelle sticks on Aquabord.

I have an affinity for peonies of any color; this bloom and its ripe buds were especially inviting. I used a combination of Faber-Castell fuchsia and madder on the peonies and accented them with Inktense fuchsia for extra brilliance. Once the leaves were thoroughly dry, I went over the shadowed areas with a diluted wash of Lyra wine red.

BOTTOM, LEFT: I created the soft-focus background of *Peony Power* by loosely scribbling with various shades of light, medium, and dark green (all from Cretacolor), then spraying the background with a water mister so the strokes dissolved. Once they were dry, I added Lyra wine red for the deepest complementary shadows and dabbed it with a Funny Brush.

BOTTOM, RIGHT: Since Aquabord has a surface made with kaolin clay, it becomes soft when wet. Vein lines for leaves can easily be incised into the damp surface with a stylus, wax carver, or nut pick. Once the Aquabord has dried completely, a wash can be added over the veins, sinking into the delicately incised lines.

High in North Cascades National Park in the state of Washington is a stunning reservoir named Ross Lake. Since the scene—and memories of that trip— were special to me, I wanted to create some North Cascades art on sanded paper with watercolor pencils. I was anxious to try "Cheap Joe" Miller's watercolor technique of creating spattered leaves by blowing watercolor pencil wash through a small screen. This also offered a good opportunity to show that water-soluble pencils—here Faber-Castell Albrecht Dürer pencils—can be used for both fluid and dry effects.

1 I selected Canson Touch sky gray sanded paper, a perfect match for the overcast sky. My line drawing simplifies the steep mountain contours, defining where the valley reservoir is. Remembering the landscape principle of background-to-foreground, I laid in strokes of Faber-Castell watercolor pencils for the water: white for the highlights, sky blue and light ultramarine blue for the furrows in the water, and light ultramarine blue and earth green light for the shadows closest to the steep shore. Because the cliffs on the right cast a shadow on the water, I kept the values darker there.

2 With a 3/8-inch dagger striper, I dissolved the streaks of white in the water, the sky blue, light ultramarine blue, and finally green earth. The darks at the base of the bluffs initially stayed dry, keeping the colors of the water light. With the dagger striper, I later dissolved the green bluff shadows, adding juniper green at the water line. When completely dry, I drew vertical strokes of caput mortuum violet for the bluffs, then lightly dissolved them with a size 4 Lizard Lick. Keeping strokes

dry, I drew walnut brown in the cracks and streaks of ivory on the faces of the bluffs.

3 I drew and washed, with a size 1 round, the distant mountains, using cool earth green light and sky blue. On the bluffs I gradually used: juniper green, permanent green olive, May green, and finally light green. I drew and dissolved, with a size 2 round, dark cadmium yellow tamarack splotches. On the closest shoreline, I dabbed caput mortuum violet. Using caput mortuum violet plus earth green light wash from a puddle of with the smallest Funny Brush, I painted the bluff. After drawing leafy, mossy greens, I washed them with a size 2 round brush. I drew the evergreen with caput mortuum violet, juniper green, permanent green olive, and light green. I restored the paper tooth, power-erasing evergreen branches. This technique is a handy form of inverse drawing.

4 I drew small trees on the left slope, heavily rendering the closer evergreen branches. With a size 2 and a size 4 reservoir liner, I sparingly wetted these wispy-needled branches; brown ochre and caput mortuum violet provided earthy slope colors. For boulders I drew, then washed: burnt umber, nougat, caput mortuum violet, and brown ochre, using ivory for highlights. While the painting was wet, I screen-grated: dark cadmium yellow, nougat, and caput mortuum violet. Clinging fragments added boulder texture. On the aspen I scumbled May green and dark cadmium yellow, using reservoir liners size 2 and size 4 for washing. I swept a dark cadmium yellow wash onto the spatter screen and blew leafy spatterings. I repeated with terra cotta, then—when the painting was dry—with ivory.

Ross Lake, Washington; Kristy Ann Kutch, CPSA, 2013, 9¹/₂" x 11⁷/₈", watercolor pencil on Touch sanded pastel paper.

8 WATER-SOLUBLE PENCIL TECHNIQUES

THINK OF A WATERCOLOR PENCIL AS A CAKE OR pan of watercolor pigment to which binder has been added. After being extruded as a thin core and encased in wood—or shaped into a woodless pencil—it offers much the same potential as pan watercolors, and more. You can draw with it dry and leave it dry, apply dry strokes and unleash wash qualities with the sweep of a damp brush, or accomplish a variety of effects with a range of other techniques.

This chapter offers suggestions for realizing the amazing potential of water-soluble drawing and painting, using those same novelty pencils which may have been languishing unused among your art supplies. Indulge in some time spent simply playing! Freely dabble and experiment: directly draw with them, wash the pigment, paint from the point, spatter from a toothbrush, and even grate these remarkable tools for special effects. Since I wrote my last book, I have learned of new-to-the-medium techniques for lifting color using stiff brushes and even a household-cleaning sponge–like eraser.

Another new technique, shared by watercolor artist "Cheap Joe" Miller, involves sweeping dissolved watercolor pencil pigment across one of his spatter screens, positioning it just above the art, and blowing hard to scatter tiny droplets of color. Since I discovered Joe's spatter-screen technique, I have used it for leaves, rocks, even fields of wildflowers. What fun!

Practice these techniques for aquarelle drawing and painting and see how stunning your aquarelle pencil art can be.

Mount St. Helens Rebirth, Kristy Ann Kutch, CPSA, 2013, 9" x 12", colored pencil, watercolor pencil, and wax pastel on Colourfix sanded pastel paper.

Mount St. Helens, which erupted in May 1980, is now a national monument, much of it still resembling a moonscape. The white stump in the foreground which appears to be driftwood is actually what remains of a tree after the extreme heat, smothering ash, and fury struck the pristine woodland. My goal was to portray the gradual recovery of the mountain in spite of its earlier devastation. I used traditional colored pencils for the sky and the land and found that watercolor pencils were perfect for painting the deep, fluid blues of the distant Spirit Lake. Water-soluble pencils and wax pastels provided the ideal means for creating vibrant flowers and brilliant white highlights on the stumps. After mulling how I could portray realistic pebbles without spending hours on them, I stroked a wax pastel wash on a Cheap Joe's spatter screen and blew the pebbles on in a matter of a few minutes.

APPLYING AQUARELLES

The approach to aquarelle pencils can be quite basic: pick up the pencil and start stroking. Better yet, pick up a brush and start dissolving. Whether you consider yourself primarily a drawing artist or a painter, such pencils deserve your attention.

Start Dry, Then Add Water

Water-soluble pencils also offer the option to draw in dry form and then wet individual aspects of your piece, one at a time. Such an approach makes it easy to draw and wash numerous petals on a flower, cherries in a cluster, or grapes in a bunch, for example. When drawing and washing objects with adjacent penciled areas, skip around the cluster and do not wet bordering areas until the neighboring zones have dried, lest the areas accidentally bleed into each other and lose their distinctness. If an object has changes in value, dissolve the pigment by moving from the light to the dark value.

When dissolving drawn watercolor pencil pigment, wash random, non-adjacent areas; this keeps clustered objects well-defined and avoids unwanted blending of colors.

Another option is to draw an object using analogous (neighboring) colors for different values of light and dark. In such an application, sweep the damp brush from the light area to the darker area to preserve the distinction of values. If you brush randomly or in a dark-to-light direction, the range of values will be lost and the area will be largely the same value.

Creating Washes

You can easily dissolve pigment on delicate areas, such as flower stamens and pistils, with liquid blending markers. However, the downside is that they dry very flat and do not achieve the same rich quality of washed aquarelle color. Introducing a brush and a bit of water gives you a host of options for creating wash effects in key areas of your work.

An alternative approach is to apply a damp brush to the tip of the watercolor pencil—stroking it several times to load it well with pigment—then paint small details with pigment taken directly from the core of the pencil itself. This technique can be used for fine petals, tendrils, delicate branches, centers of flowers, even your signature.

Liquified pigment, loaded on a brush, can be also be touched into a damp area which has been freshly washed. This creates a flowing wet-into-wet plume of rich color.

To achieve a powerful burst of dramatic color, you can wet an area on the art surface and then also wet the tip of the aquarelle pencil. Draw with the damp pencil tip in the freshly washed area for a very intense wet-into-wet stroke. Allow the pencil tip to dry before sharpening it, since it is more delicate when wet.

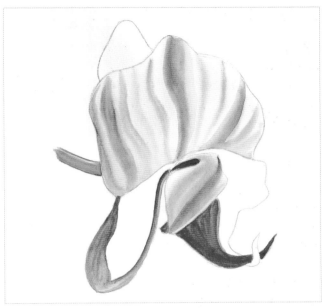

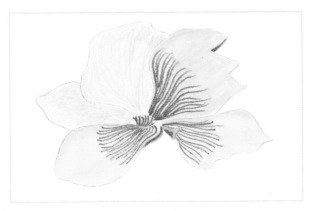

TOP, LEFT: A fine, wet brush can be used to pick up pigment from the tip of a water-soluble pencil to directly paint fine details.

MIDDLE, LEFT: Dissolving watercolor pigment from light to dark maintains the distinct values, instead of the uniform hue which results from moving from dark to light values.

BOTTOM, LEFT: Dragging a wet watercolor pencil tip through a damp area yields intense linear color.

TOP, RIGHT: Flowing color results from painting into a damp area with a brush loaded with pigment taken directly from the point of a watercolor pencil.

A customized palette is the ideal solution for the artist with a small set of pencils or a desire to spontaneously blend a combination of colors and practice some "mixology." It is also an excellent way to experiment, learning how hues behave when mixed.

1 To create a convenient puddle of wash, I simply scribbled a heavy swatch of watercolor pencil—or several shades of pencil—onto a small panel of Aquabord or a small piece of gritty paper.

2 I then wet the palette so that the pigment dissolved into a puddle of watercolor wash, ready for painting details with a brush.

3 Using such a palette, I could not only draw on the sanded art surface, but could directly paint *from* dissolved pigment prepared on a homemade palette. I have small Aquabord panels which have dried pigment on them from months, even years ago, but all I need to do is add water and the liquefied pigment reactivates, ready to be used.

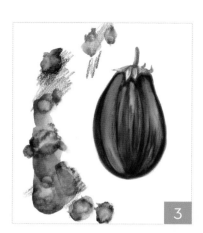

Building Color with a Complementary Underpainting

Underpainting with complementary color is an easy way to add vibrant dimension to your color layering. I have learned that it is vital to allow the underpainting to dry thoroughly before adding other layers. Otherwise, instead of veils of translucent color, the result is unintended neutrals. Remember these four little words: "Let it dry completely!"

1 I created an underpainting of a complementary color and allowed it to dry completely.

2 I then drew the desired hue over it with a watercolor pencil.

3 I dissolved this second layer with a sweep of a damp brush, trying not to let the two colors mix. Too many brushstrokes might disturb the underlying layer, yielding a muddy effect or an undesired neutral hue instead of the desired layers of color. This technique gives a vibrant interplay of overlapping complementary colors.

Grating Pigment Over a Wet Surface

Grating pigment over a wet surface lends a beautifully random speckled look in a matter of minutes. It is ideal for rendering granite, mosses and lichens, sand, gravel, delicate masses of distant flowers in landscapes, freckled or spotted regions on individual flowers, or even pollen.

1 I created a drawing of an antique fishing lure, which will receive the grating. I had these materials ready: water, desired hues of watercolor pencils (Faber-Castell Albrecht Dürer olive green yellowish and walnut brown), and a grating tool (I used a strainer, but a mesh screen, tea strainer, or sandpaper would work as well). It is important to have these supplies at hand, since there is a short window of opportunity for grating, when the surface is wet.

2 With a medium round brush, I lightly wetted the area to receive grating. I used a damp (but not heavily dripping) brush, making certain to keep the clear wash within the drawing line and away from the highlights.

3 Using a mesh screen, I grated the watercolor pencil tip over the moistened area. This process allowed the water-soluble granules to fall onto the wet surface, dissolve, and bond to the painting (even one done with traditional, non-watercolor pencils). I quickly repeated this grating process with other desired colors, aiming to complete the entire grating process while the surface was still damp. Any stray granules which fell outside the desired area could be lightly blown away, since the pigment only clings to the areas which have been wetted.

Glazing

Glazing is a way to add light, transparent veils of overlapping color to warm or enhance the mood of a subject—much like an interesting harmony in music.

Glazes are layers of color put down one by one, allowing ample drying time between layers. Glazing can be done either with dry aquarelle pencil that is drawn and then liquefied on the surface or—more cautiously—it can be painted on as a ready-made wash from a puddle of dissolved pigment. I usually start with dry watercolor pencil then liquefy after drawing and add washes for later layers.

I appreciate the very staining and permanent watercolor pencils Caran d'Ache Museum Aquarelle and Derwent Inktense. Both brands are excellent for creating permanent layers of aquarelle color. Once a wash made with either of these types of pencils has dried, this underlying layer will remain intact and undisturbed by overlapping glazes.

TOP, LEFT: I drew a layer with yellow watercolor pencil and then washed the area so that the pigment was dissolved. To show the contrast between dry and dissolved color, I left part of the yellow section in its dry state. It is very important to allow the surface to dry thoroughly.

TOP, RIGHT: Overlapping yellow and red swirls of watercolor pencil produce orange.

BOTTOM: Likewise, with the addition of blue, overlapping swirls render green and violet.

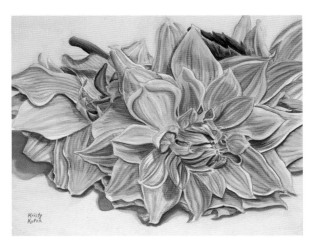

Farmers' Market Dahlias, Kristy Ann Kutch, CPSA, 2013, 15" x 12", watercolor pencil and colored pencil on Strathmore Illustration Board for Wet Media.

My local farmers' market provides plenty of reference material and inspiration. I bought these dahlias with waxy colored pencil art in mind but eventually recopied my line drawing and started it again as an aquarelle demonstration. After I drew the colors onto each petal, I wetted them one at a time. In some of the areas closest to the center, I glazed with an additional layer of cadmium yellow.

CONTROLLING AND LIFTING WATER-SOLUBLE COLORED PENCIL

We all encounter slips of the hand and runaway washes. Even if the error cannot be erased completely, it can usually be tweaked.

Solutions for Still-Wet Pigment

For a quick fix when there is too much wash, I dab or wick the surplus liquid with a tissue or paper towel. However, this speedy approach may alter the whole watercolor effect and can dry the area *too* much. Blotting may even be too drastic, depending upon the effect desired. To better preserve the wash, I wick the excess liquid by barely touching it with the corner of a tissue or paper towel, allowing the wash to travel up the paper. A thirsty brush can also be easily swept across the damp surface, lifting and lightening an area that has become too saturated. A thirsty angle shader, dagger striper, or the side of a flat brush can be especially well-suited to this process of lifting, and correcting.

When the surface is suitable, a scrubber brush effectively lifts watercolor pigment, leaving a lightened, scrubbed area. Avoid scarring or damaging the surface of the watercolor paper by experimenting first on a scrap of the same type of paper.

You can lift watercolor pigment from either heavy paper or a board surface with a Mr. Clean Magic Eraser. Simply wet the Magic Eraser and lightly sweep—do not scour—it across the color to be lifted. The pigment clings to the Magic Eraser, which can then be rinsed clean. The Magic Eraser can also be cut with scissors into sharp wedges for precise lifting in tight spaces.

Watercolor pencil pigment can be lifted using a thirsty brush (left), scrubber brush (middle), or Magic Eraser household cleaning sponge (right).

Solutions for Dried Pigment

Once the washed pigment has completely dried, there are dry methods for lightening and lifting. A kneaded eraser can be dragged across the painted area for some light lifting. A white vinyl eraser, especially a battery-powered white eraser, is helpful in color-lifting and erasing, even on Aquabord. Do not use any eraser, especially a whirring battery-powered eraser, while there are still damp areas on the painting. Tiny eraser crumbs fly in all directions and can cling to a moist area, ruining a smooth wash.

CREATING VIGNETTES AND DYNAMIC BACKGROUNDS IN WATERCOLOR PENCIL

Aquarelle pencils hold great potential for dealing with that daunting background (the *negative* space!), transforming it into something beautifully enhancing and fearless. I devoted an entire chapter to backgrounds in *Drawing and Painting with Colored Pencil* (Watson-Guptill, 2005), and was gratified at the wonderful comments from readers who appreciated those demonstrations. Since then I have become more inventive and confident with water-soluble pencils and share some painless options here.

Simple Ways to Fill Negative Space with Watercolor Pencil

For compositions where the subject occupies the majority of the surface, controlled, dense water-soluble backgrounds often work best. To get this effect, pencil in the negative space with even layers of color and then wet each section of the background one at a time.

A speedy way to create background is to paint directly from a wash. Simply scribble the watercolor pencil heavily onto the customized palette, using a small panel of Aquabord. Add water and dissolve into a small puddle of liquefied pigment and paint it into the negative space. For a very soft aqueous effect that is less dense, first wet the background with clear water and then apply the dissolved colored wash.

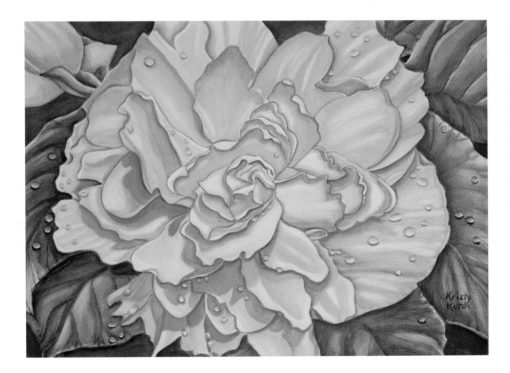

Dewy Begonia, Kristy Ann Kutch, CPSA, 2013, 14" x 11", watercolor pencil on Aquabord.

Dewy Begonia is an example of a composition that is full to the brim. With its dark green background, the dewy yellow blossom fairly pops from the contrast. The negative space, which adds to the pop, was easy to do: I heavily stroked watercolor pencil in chrome oxide green and wetted each segment. Since this was done on Aquabord, the dissolved color was intense. Once the background greens were dry, I decided to deepen them even more, painting more chrome oxide green directly from a puddle of liquefied pigment.

Creating a Liquified Aquarelle Vignette

As discussed in Chapter 5, vignettes are lovely and efficient solutions for enhancing negative space. A liquefied aquarelle vignette offers a speedy and fluid background option. I practiced this background technique on scrap paper with an angle shader and dagger striper brush. Both of these types of brushes work well at evenly reaching curves and nooks.

1 I used the side of the watercolor pencil to draw a band of light olive (Caran d'Ache Museum Aquarelle) which hugs and surrounds the composition. I avoided making sharp, pointed lines which might not dissolve smoothly. If I had wanted hints of obvious directional strokes, I would have used the pencil point.

2 With a 3/8-inch wide dagger striper brush, I applied a light wash of clear water just outside (not quite touching) the penciled border of the orchid. I dabbed off the brush and reloaded it with clear water when needed, continuing my damp border around—but not yet touching—the colored band. Reloading the brush with clear water, I lightly dabbed it once on tissue to remove some of the water and control the wetness. I slowly swept the bristles over the colored and wet areas of the painting so that the brush straddled the clear, wet zone and the band of dry watercolor pencil.

3 I continued the rest of the way around the orchid. This process dissolved the water-soluble pencil and created a graduated wash. I brushed around the vignette again, continuing the sweep, dissolving the band of watercolor pencil even more thoroughly. Once this dried, I was ready to work on the orchid.

Creating a Spattered Background

It is very easy and inexpensive to create an attractive airbrushed effect for your background. Using watercolor pencils, a soft toothbrush, and low-tack frisket film, a spattered background is a speedy and loose solution. It takes some practice flicking the pigment with a toothbrush, but the resulting effect can be well worth it. All of the permanent pencils I used for this demonstration were Caran d'Ache Pablo pencils, with Caran d'Ache Museum Aquarelle pencils for the spattered background.

1 I prepared a line drawing of three different kinds of apples, using Stonehenge Kraft paper, a tan paper that accepts many layers of colored pencil.

2 I used aubergine for cast shadows. Applying olive brown on stems, I added strokes of pale yellow on the light sides and dark carmine on the shadowed sides of each apple. On the golden delicious apple, I stroked golden ochre, lime green, and green ochre, indicating a white highlight. I used moss green and khaki green for the darker areas, with pale yellow and Naples yellow on the sunnier parts. On the red delicious apple, I used scarlet strokes. In its darker areas, I applied carmine and dark carmine, adding moss green, followed by vermilion, on the sunny face of the apple. Golden ochre provided the honeycrisp apple undercoat, with scarlet and carmine along the edges. I finished the honeycrisp by edging with a sharp dark carmine pencil.

3 I placed some Artool low-tack frisket film, shiny side up, over the drawing of the three apples. It is very important to place the film shiny side up, or else it will result in a mirror-image pattern. With a fine-point permanent marker, I traced just the outline—not the shadows—of the group of apples.

4 I cut out the pattern of the apples (and saved the frisket film scraps, as they are excellent for erasing and lifting techniques). Then I peeled the film from the backing paper and gently placed the pattern right over the apples, to act as a shield from spatters. Once the paper has been peeled from its backing, this film is so transparent that you have to look closely to see it.

5 I loaded a wet, soft adult toothbrush heavily with watercolor pencil pigment, stroking the watercolor pencil core directly across the damp bristles. It can take ten to twenty strokes to saturate the toothbrush with color. I lightly dabbed the brush on tissue four or five times, to remove excess water and make the wash easier to control.

6 With my thumb against the head of the toothbrush, I flicked the pigment onto the surface, concentrating the spatter most heavily around the apples by holding the brush only about 1 or 2 inches above them. (When there is a too-large splatter, I quickly correct it by wicking, not blotting, the droplet.) For multiple colors, I allow the surface to dry for fifteen to twenty minutes before adding another layer of spattering.

7 After the spattered background was completely dry, I gently peeled back the frisket film to reveal the finished piece. If there were any gaps in the spatters near the apples, I took a sharp pencil and dotted in little specks to look like the missing spatters.

 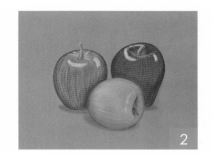

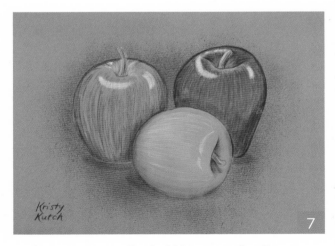

Apple Trio, Kristy Ann Kutch, CPSA, 2013, 14" x 11",
colored pencil on Stonehenge Kraft paper.

Sometimes background vegetation in a floral or landscape reference can appear too busy, competing with the main subject. In such cases, you can suggest soft-focus vegetation in the background by drawing with watercolor pencil, then misting the area with water.

I chose this hibiscus to show off a dazzling palette of Derwent Inktense water-soluble pencils both with the flower in the foreground and the greenery behind it. Pairing them with Ampersand Aquabord and its bumpy, toothy surface, my goal for this painting was maximum saturation.

1 I completed the basic line drawing and protected the hibiscus blossom and stamens with masking fluid. Masking fluid is a liquid that dries into a rubber cement–like film. It should be quickly applied to the area to be saved from watercolor washing, using a cheap brush, knitting or darning needle, toothpick, or even a sharpened twig. Once the watercolor pigment has dried completely, it is safe to gently peel back and discard the rubbery peeling. I quickly applied the fluid along the edges of the flower, aiming to prevent splattering of the background colors onto the blossom petals.

2 I loosely scribbled Inktense background colors: sun yellow, sherbet lemon, beach green, and Ionian green. Making sure to include areas of dark, mid-value, and light in the background, I wanted to give this soft-focus background some colorful variety. Keeping the painting flat, I lightly spray-misted the background; it looked very pointilistic and dotty. After spraying with a light mist

several times, I used the tip of a size 6 round brush to coax the colors to blend, being careful, however, not to over blend them. Notice the difference between the sprayed and unsprayed sides. I then left the painting on a level surface to dry completely.

3 I finished spraying the leafy background and let it dry. I enriched the green hues by adding another layer, followed by spray-misting. Once everything was dry, I stroked more Ionian green in the darkest areas, sprayed again, and let the Aquabord dry. I peeled off the masking layer along the edges of the blossom, leaving just the stamens covered with the dried mask until I was finished dissolving the petals around them. I then drew colors on the hibiscus blossom, petal by petal, using sun yellow, tangerine, and poppy red. On the leaves I used sun yellow, sherbet lemon, and beach green.

4 I dissolved sun yellow, then tangerine and poppy red, on each petal, using sizes 2, 6, and 10 round brushes for progressively larger petals. I washed the leaves, suggesting veins with the edge of a thirsty angle shader brush. From a palette of diluted poppy red, I painted the leafy shadows at the top of the painting. Along the petal edges I painted a fine line of field green wash plus leaf green. After drying, I peeled off the remaining mask. I drew stamen tops with sun yellow, dissolving them with a size 2 reservoir liner, then adding poppy red. I washed only the stamen sides with diluted sun yellow and poppy red and left the rest white.

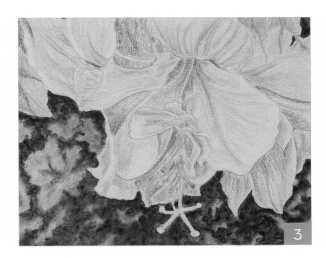

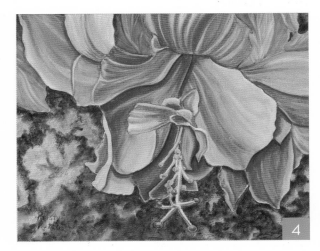

Hong Kong Hibiscus, Kristy Ann Kutch, CPSA, 2013, 11⅞" x 9½", watercolor pencil on Aquabord.

WAX PASTELS AND COMBINING COLORED DRAWING MEDIA

9 WAX PASTELS, COMPATIBLE SURFACES, AND TECHNIQUES

THEY LOOK LIKE FAMILIAR CHILDHOOD CRAYONS, stroke with similar ease, and even sharpen like them, but their rich, vibrant color sets wax pastels apart. Although they are commonly called artist's crayons, wax pastels are in a different class of colored drawing medium.

Another source of confusion is the fact most people associate the word pastel with the hard and soft variety of pastels—the kind which lay down a dry, powdery form of pigment. Wax pastels, in contrast, have a glossy, softly waxier nature. And soft pastels feature a dryer, more powdery composition.

Fine art wax pastels are made through a long, complex extrusion process, which yields a high product density and opacity. Beyond the mix of paraffin and pigment that normal crayons have, they contain finely ground pigment, quality synthetic art waxes, talc, and titanium dioxide. The result is richer pigmentation and greater concentration of densely colored product. (Caran d'Ache notes that due to their wax content and high quality pigments, their wax pastels have superior lightfastness, yet another notable advantage.)

Formerly, wax pastels were considered to be in the realm of colored pencils. Today they stand in their own category as an immensely popular drawing tool available in an impressive range of colors.

PREVIOUS PAGE: *Philipson's Annie*, Mary Hobbs, CPSA, 2005, 13" x 8", India ink, acrylics, watercolor pencil, and colored pencil on 5115 Crescent watercolor board.

Annie is the dog featured in Sandra Philipson's children's book *Max and Annie*. Mary Hobbs first applied India ink to all of the dark areas on Annie and to the striped background, followed by a wash of thinned gray acrylic as an undercoat over any lighter areas. Wherever there was to be white, she applied white colored pencil first to create a resistance to the watercolors, which were added later. Finally, she added layers of waxy traditional colored pencils, using gold, green, and brown watercolors for Annie's eyes. Mary prefers 5115 Crescent watercolor board because it accepts all mediums, layer after layer of pigment can be applied, and it is very forgiving.

NEXT PAGE: *Illuminated Tulips*, Kristy Ann Kutch, CPSA, 2013, 12" x 16", wax pastel on Colourfix plein air board.

These everyday wonders bloom each spring around our birdbath. Because wax pastels lend themselves well to large strokes of color, they were a perfect match for the bold sweeps of the glowing tulips. With a choice of sanded Colourfix leaf green dark plein air board, meant the background was ready-made and the painting was finished quickly.

WATER-RESISTANT (OR PERMANENT) WAX PASTELS

Like colored pencils, wax pastels come in both water-resistant (or permanent) and water-soluble (or aquarelle) forms. Water solubles offer much more variety in terms of effects they can create and different makes, but water-resistant wax pastels do have their own unique qualities and are indeed worth exploring.

The permanent wax pastel is well-suited to quick, linear drawing. Think in terms of bold strokes and larger areas of color for wax pastel, rather than small, meticulous details. The Swiss company Caran d'Ache launched the Neocolor I permanent wax pastel in 1952, and it is the most notable water-resistant pastel. Containing between three and four different waxes and between 5 and 40 percent pigments among the hues, the Neocolor I is loaded with color. Layering and overlaying colors are easy processes, and Neocolor I is highly lightfast due to the nature of these high-quality waxes.

The Neocolor I wax pastel has the interesting trait of becoming permanently water-resistant. I watched a demonstration of this at a trade show and was fascinated by the simple process. When the artist finished drawing the piece with Neocolor I, he buffed the surface—which was stone, but could be wood, slate, as well as more traditional surfaces like Bristol board or paper—with a soft cloth. He sprayed the stone demonstration piece with water and wiped it

dry: the wax pastels were unaffected. When Neocolor I has been drawn and buffed on a surface which might be exposed to water, such as outdoor art, the droplets simply bead up without damaging the art.

Most wax pastels can be sharpened to a point with a razor blade or with the larger hole of a hand-sharpener. You can simply draw with them and leave the lines untouched or manually smooth them with a blending pencil or cardboard blending stomp. Blending markers containing alcohol solvent fluid are also effective with water-resistant wax pastel. Heat-blending with an Icarus Board or heat gun is easy, too, leaving the blended color with a glossy surface.

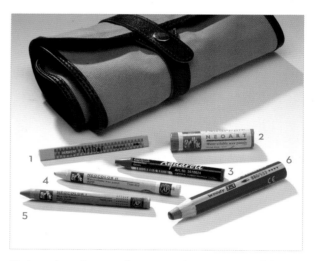

Six brands and types of wax pastels, varying in solubility, size, shape, and color selections: 1) Derwent Artbar, 2) Caran d'Ache NeoArt, 3) Lyra Aquacolor, 4) Caran d'Ache Neocolor II, 5) Caran d'Ache Neocolor I, 6) Stabilo Woody.

WATER-SOLUBLE (OR AQUARELLE) WAX PASTELS

Since the 1975 invention of Neocolor II by Caran d'Ache, the water-soluble wax pastel has grown in popularity and variety. It is commonly referred to as an artist-grade watercolor crayon, but just like the water-resistant variety, it is so much more than that. Although aquarelle wax pastels do not offer the fine drawing precision of pencils, they are easy to use, richly colored, and surprisingly speedy.

Several companies offer such aquarelle products in a wide array of colors and even in metallics. Caran d'Ache Neocolor II—which contains the same ingredients as the water-resistant Neocolor I, but which is bathed in water-soluble wax at the end of the manufacturing process—has the largest color range, including metallics. The company's more transparent, less opaque NeoArt line is very concentrated, enough to load a brush and paint directly from it. Derwent of Great Britain has launched Artbars, triangular cross-sectioned sticks that offer six drawing points, plus an array of useful accessories to use with them. Artbars' shades include a great range of colors for sea, sky, land, foliage, and rocks. Lyra of Germany markets vivid hues of Aquacolors, slightly larger in diameter than the Neocolor IIs and Artbars.

The most obvious way to use a wax pastel is to simply stroke its rich color onto the art surface and draw with it. To blend the strokes, either layer and build other colors over them or manually smudge the pigment. Using a blending stomp in the appropriate size or a stiff blending brush (such as a pastel blending brush or stencil brush), causes the wax pastel surface to become smoother in texture. Blending with heat also works well.

Another speedy way to blend watercolor wax pastels is to stroke them onto the surface and then dissolve the pigment with water. Sweeping a damp brush over the drawn area instantly transforms it from the more granular dry medium to a smooth, liquefied wash.

Whether working with wax pastels wet or dry, I have discovered that they can smudge pigment on my damp hands and fingers. Cleanup with soap and water is easy; just make sure to dry your hands well before handling any more wax pastels.

Creating Bold Backgrounds and Sumptuous Skies with Aquarelle Wax Pastels

Because wax pastels dry to a more opaque finish than watercolors or watercolor pencils, and because of their dense color and easy solubility, they are wonderful for quickly creating a number of different lovely backgrounds.

Opacity and covering power vary among the lines of aquarelle wax pastel. NeoArt by Caran d'Ache dries to a less opaque, more translucent finish, for example. Some characteristic waxiness is still apparent on even the dried surface, but, dried pigment can usually be lifted with a battery-powered white eraser, allowing for tweaking and correcting.

This medium is well suited to the application of a single layer which is washed and then left to dry. Unlike some of the watercolor pencils, aquarelle wax pastel pigment is not permanently staining. Rewashing subsequent watercolor wax pastel layers disturbs the underlying color, even if the first layer is thoroughly dry. Mixing complementary colors by rewetting the underlying wax pastel layer can result in an undesired neutral. Creating depth and dimension with this product is better suited to drawing and then washing analogous colors (such as a darker shade of the same color or its adjacent neighbor color), rather than underpainting with complementary colors.

Painting Directly from Water-Soluble Wax Pastels, Plus Other Techniques

Aquarelle wax pastel is so heavily pigmented and easily dissolved that it can go beyond obvious stroke-and-wash application. It is possible to create an entire piece—even a detailed rendering—just by painting directly from the stick. These products are so concentrated that surprisingly little of the wax pastel stick will be gone when a painting is complete.

Chick, Jackie Treat, 2011, 5" x 7", colored pencil and watercolor wax pastels on Pastelbord.

Jackie Treat began by "playing around" on colored surfaces, with very little reference material. This charmer is the result of that experiment; the toned Pastelbord is the perfect, simple ground for the bold patterns on the body of the chick. Jackie likes to use an underpainting of Neocolor II for its smooth coverage, especially when she is planning to add many layers of color.

WAX PASTEL COLLECTIONS AND TRAITS

PRODUCT NAME	NUMBER OF SHADES	PRICE LEVEL	KEY CHARACTERISTICS
Caran d'Ache NeoArt	60	High-end	Densely concentrated, not widely distributed
Caran d'Ache Neocolor I	50	Mid-range	Unique glossy, water-resistant formula
Caran d'Ache Neocolor II	126	Mid-range	Water-soluble, very widely distributed, great solubility
Derwent Artbar	72	Mid-range	Excellent for flowers, foliage, rocks
Lyra Aquacolor	48	Budget-friendly	Great color palette for the price
Stabilo Woody	18	High-end	Wide core jumbo pencil–like construction, water-soluble

USEFUL ACCESSORIES FOR WATER-SOLUBLE WAX PASTELS

Stabilo Woody wax pastels are large, looking much like chunky jumbo pencils. For this reason, the company has designed a special sharpener. When sharpening just the tip (not the wooden casing), save the shavings for other aquarelle effects.

Derwent offers tools specifically for their aquarelle wax pastel products. These include Shave 'n Shake, a jar with a lid that features a built-in triangular metal sharpener for Artbars. The Shave 'n Shake also captures the Artbar shavings in the jar so that they can be liquefied or scattered onto a wet surface. The Scraper offers numerous sharp edges for incising and for sgraffito, scraping away a top layer to reveal underlying layers. The pocket-sized Spritzer is a convenient plastic water sprayer with a lid, about the size of a test tube. This handy little tool can be used for wetting pre-drawn watercolor pencil or watercolor wax pastel to loosely dissolve it. The manufacturer also suggests using its mist to maintain a wet working area for wet-into-wet techniques. Another option is to dissolve water-soluble *pencil*, such as Inktense, into a wash, pour it into the Spritzer tube, and then spray it.

BOTH DERWENT AND STABILO OFFER CONVENIENT TOOLS FOR SHARPENING, SHAVING, SCRAPING, AND MISTING WAX PASTELS.

LEFT: *Crocus Heralds*, Kristy Ann Kutch, CPSA, 2013, 12" x 15", watercolor pencil and water-soluble wax pastel on Strathmore Illustration Board for Wet Media.

To create the mulch around the crocuses, I scumbled wax pastel strokes in spring green, moss green, green ochre, raw sienna, olive brown, burnt umber, and touches of purple violet. I then barely dissolved them, using a round stencil brush. After I completed this large area of background, I felt as though I was half-finished with the painting!

RIGHT: *Solitary Peony*, Kristy Ann Kutch, CPSA, 2009, 9" x 12", water-soluble wax pastel on Strathmore Imperial hot-press watercolor paper.

I had just returned from an art-supplies trade show and had seen Caran d'Ache NeoArt being demonstrated. Much to my amazement, the salesman was using a damp brush and directly painting with rich color directly from the cylindrical NeoArt stick. I eagerly bought my own set and painted this peony entirely by brush, stroking directly from the NeoArt, like painting from a pan of watercolor.

Beverly Shores Lilies, Kristy Ann Kutch, CPSA, 2012, 11" x 16", water-soluble wax pastel on Strathmore Illustration Board for Wet Media.

As I was visiting the local post office, I spied a bed of gorgeous shrimp-colored lilies, just waiting to be photographed. Once I had my digital image, I cropped it tightly; the petals were then large, quite suitable for the broad strokes of a wax pastel. I used Neocolor II and NeoArt, simply drawing on the colors. Once they were activated (washed) with a dagger striper brush, it was fun to see those lush, waxy colors emerge.

Creating Customized Washes and Grating Water-Soluble Wax Pastels

It is also convenient to create a customized wash of dissolved wax pastel by scribbling heavily onto Aquabord and adding water, as described for water-soluble pencils in Chapter 8. With this dissolved pigment, it is possible to create a more diluted, transparent wash than the usual opaque finish of watercolor wax pastel. Such a liquefied puddle can even be used for painting more delicate details, spattering with a toothbrush, or for rendering crisper edges with a fine brush.

Watercolor wax pastels can even be grated onto a wet surface with large metal mesh, rendering speckles of sand, gravel, moss, or pollen. Note that these fragments may not cling and bond to a wet surface as well as grated bits of water-soluble colored pencil do. It may be necessary to give them a few light spray mists of water or use a heat gun to lightly melt such speckles into place.

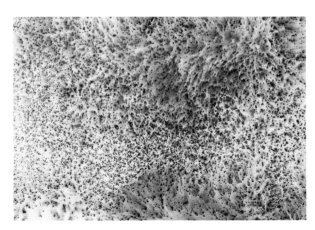

I washed Carteira Magnani Acquarello 140-pound hot-press watercolor paper with clear water and a 2-inch wide flat brush. Using Caran d'Ache NeoArt wax pastels, I quickly grated sky blue, permanent blue, and Prussian blue through a mesh screen, right over the damp paper. The grated shavings dissolved when they touched the damp paper. The grated shavings were further dissolved when they were sprayed with a water mister, and look very aquatic.

SIMPLE, CUSTOM-TONED SURFACES

My friend, Oregon artist Laura Miller, enjoys working on suede-like mat board. She tints her suede board with diluted Neocolor II wash to make a custom-toned surface. (She cautioned me that it takes practice to get the right amount of wetness to the wash; if it is too watery you'll get a watercolor bloom effect.) Once it has dried, she has a board in her desired base color and is ready to draw upon it.

Simple Approaches for Permanent Wax Pastel

**Keeping in mind that larger subjects with less detail
are more suitable for wax pastels, mushrooms and
bright peppers appealed to me for this demonstration.
Neocolor I is a highly lightfast medium fitting for
a quick and vivid piece of art, and I was happy to
discover that the Full Blender Bright blending pencil
works with this medium, as well. There is a comfortable
familiarity—much like using crayons—in picking up a
wax pastel and simply enjoying strokes of those rich,
waxy colors.**

1 On Pastelmat paper, I completed the line drawing
of peppers and mushrooms. I indicated highlights
with the point of a Sahara yellow Neocolor I wax pastel.
For the pepper on the left, I added strokes of orange,
following the contour of each section of the pepper. For
the pepper, on the right, I did the same with a yellow
Neocolor I. When I lifted the orange pepper on the left
with a white vinyl battery eraser (with mixed success),
I had to clean the eraser well afterward on a piece of
sandpaper; the eraser itself accumulates heavy pigment
and I didn't want this color to come off on my artwork
the next time I used the eraser.

2 I applied white as the highlights of the mushrooms
and also on the stems. Then I incised lines into the
stem areas of the mushrooms and peppers. On both
peppers I added vermilion along the soft furrows,
followed by scarlet and alizarin crimson on the pepper
on the left, especially near the creases. I then used alizarin
crimson, a cool red, on the more distant areas which
taper away from the viewer's eye. Moving to the yellow
pepper, I added light touches of alizarin crimson along
the furrows.

3 On the incised stems I applied dark olive and alizarin
crimson on the shady areas, adding Sahara yellow
highlights. Enriching the red pepper's colors, I added
flame red, orange, and alizarin crimson again. Using a
Full Blender Bright blending pencil, I blended the red
pepper, one segment at a time. On the yellow pepper I
stroked yellow, ochre, and flame red in the furrows.
I followed with the blending pencil, then repeated the
colors. In areas needing smooth color transitions, I
blended with a stomp. I used ochre and sanguine on the
baby Portobello mushrooms, brown in the darkest areas.

4 To ground the simple composition, I added layered
strokes of alizarin crimson and flame red underneath
the grouping, with a fine line of Sahara yellow along the
edges of the mushrooms. To add hints of reflected colors
on the mushrooms and yellow pepper, I also applied
light touches of flame red. To finish, I used fine touches
of sharp Tuscan red and violet Verithin pencils for very
crisp edging.

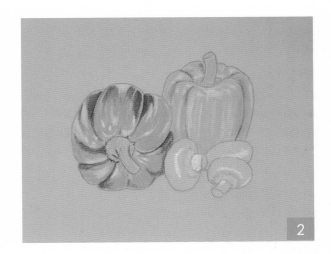

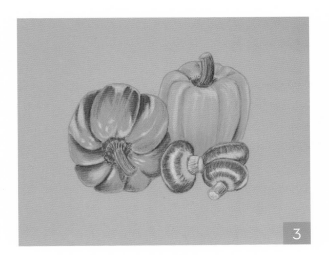

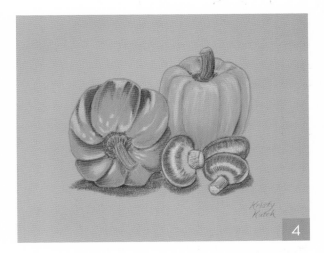

Peppers and Baby Portobellos, Kristy Ann Kutch, CPSA, 2013, 11⁷/₈" x 9¹/₂", permanent wax pastel on Pastelmat pastel paper.

I have discovered that liquefied wax pastel is wonderful for suggesting the swirls of background leaves. By using a thirsty dagger striper or angle shader brush, you can lift out the light shapes and forms. In just a few minutes this technique gives the effect of muted background foliage. Working with wax pastel wash reminded me of the long ago joy of making gestural swirls with finger paint!

1 After layering dry strokes of Neocolor II in dark green and olive black on Strathmore Illustration Board for Wet Media, I used a 2-inch wide flat brush to activate the entire area so that the pigment dissolved but did not leave puddles.

2 Using a twist of my wrist and a thirsty angle shader brush, I swept out shapes resembling leaves and stems. Because the wash is so waxy, I needed to rinse and wipe my brush often. For some extra dimension, I stroked warm yellow green and lemon yellow on some of the blades and did not even dissolve them.

Painting Directly from a Water-Soluble Wax Pastel Stick

Using pigment and a damp brush, I discovered that I can paint directly from the stick as I would from a cake or pan of watercolor. Wax pastels, so highly loaded with pigment, are well suited to this technique, enabling me to pick up plenty of pigment for painting with the brush.

1 After creating a line drawing of the three fishing lures, I stroked a damp size 4 round watercolor brush directly against the Caran d'Ache NeoArt wax pastel to load it with rich color. Using phthalocyanine blue and gold (which looks like a pale grayish aqua), I painted the back and belly of the top lure, adding scarlet for the mouth. On the bottom lure I used burnt umber, indigo blue, reddish orange, scarlet, and yellow. For the head of the fuzzy lure I used yellow green and emerald green. I painted each area one by one, avoiding having adjacent wet zones to keep the damp pigment from running together.

2 I decided to paint the more delicate features on the lures (with a deep breath and a steady hand). Since I like crisp detail, my usual course is to wet a small reservoir liner brush, a Lizard Lick size 2, with damp pigment and use it to make precise, crisply defined edges and fine details. For the fuzzy lure on the left, I picked up pigment directly from NeoArt yellow green, emerald, yellow, scarlet, reddish orange, and Derwent Artbar kiwi wax pastels and stroked in fine hairs with a Lizard Lick size 2 brush. I also used that tiny brush to paint the hooks and connecting rings with pigment from a Derwent Artbar indigo blue pastel.

Water-soluble wax pastels, with their potential for broad or pointed strokes, are well-suited to quick landscape drawing. I was curious to try Derwent Artbars, which offer an excellent range of great colors for sea, sky, land, foliage, and rocks. This scenic view at Cadillac Mountain, a peak in Acadia National Park on coastal Maine, has always appealed to me.

1 Using a ruler, I determined and sketched the horizon line on Canson Touch sanded pastel paper. I noted where the sky meets the Atlantic Ocean, since it should not be at the halfway point of the composition. With Derwent Artbars water-soluble wax pastels, I horizontally streaked in sky colors, overlapping one zone of colors into the next. Closest to the horizon, I applied blue lace, then overlapped these drawn strokes with baby blue, transitioning to an overlapping area with the deepest hue, Pacific blue. At the top of the composition, as the dome of the sky deepens and becomes more intense, I used only Pacific blue. This overlapping of blues created a smoothly graduated sky.

2 I then wetted a wide flat brush—here an angle shader brush, though a 1-inch wide flat brush would also work—dabbing it off once or twice to remove excess water. Beginning at the horizon line, where the lightest values (blue lace) are, I ran the flat, wide part of the brush over the wax pastel area, parallel to the horizon. I then repeated this process, making certain that all of the wax pastel was dissolved. Continuing to wet bands of the sky upward to the deeper blues, I overlapped the parallel strokes to blend the sky into softly graduated shades of blue. This sanded Canson Touch paper takes longer to dry, but that can be a benefit, since it allows more wet-into-wet time for rendering skies. I let the sky dry thoroughly before moving to the next step.

3 I drew, then washed, a narrow band of Pacific blue as ocean. After that dried, I used cactus and green earth to draw the distant evergreen trees, adding alizarin crimson for depth. Painting from a wash of cactus and Prussian blue with a size 4 Lizard Lick brush, I rendered dark, distant pines. I used the same colors for the shrubbery, alizarin crimson for shadows, and kiwi and primary yellow as highlights. I sparingly washed the shrubbery with a small, round scrubber brush. For ledges and boulders, I used pink oxide and beige, with wheat and opaque white as highlights, and lines of deep aqua for the cracks and gaps. I left the rocky path and ledges undissolved.

4 I drew the foreground vegetation with a combination of cactus and kiwi, adding touches of alizarin crimson for depth and primary yellow for highlights. Using a scrubber brush and a dabbing motion, I dissolved the greenery colors. For the large pink granite boulder in the foreground I used violet earth, pink oxide, beige, wheat, and opaque white, with deep aqua and burnt umber for the shadows and deep furrows. I dry-blended these with a blending stomp and a heavy hand. For greenery highlights, I added sharp strokes of opaque white, followed by primary yellow. I washed my smudgy hands well after this drawing session.

Cadillac Mountain Granite, Kristy Ann Kutch, CPSA, 2013, 9½" x 11⅞", water-soluble wax pastel on Canson Touch sanded pastel paper.

10 COMBINING COLOR DRAWING MEDIA

EACH TYPE OF COLORED DRAWING TOOL DESCRIBED in this book offers its own unique appeal. But they should hardly be relegated to working only with their own kind. On the contrary! When combined, these media can enhance and augment one another to create terrific effects. The possibilities are endless.

Watercolor pencils or watercolor wax pastels can be applied and then dissolved into a wash to create a smooth underpainting, or base layer, for dry colored pencil. More permanently staining aquarelle pencils are also helpful in creating underpaintings for water-soluble wax pastels.

Layering of traditional colored pencils on top of water-soluble drawing materials can add definition, intensity, and gloss. Even a subtle touch of precise permanent colored pencil, such as the super-sharp Verithin, quickly defines a crisp edge.

Meanwhile, wax pastels, with their densely opaque qualities, lend a jolt of strong, punched-up color to colored pencil paintings. Adding emphasis to brilliant flowers, intense skies, and frothy waves, wax pastels are much more than high-end crayons.

This chapter offers suggestions for combining the appealing traits of each of these luscious forms of colored drawing media: With their comfortable familiarity and handling ease, traditional colored pencils are the heart of colored drawing; water-soluble pencils and their smoothly flowing washes have a fluid appeal; and for convenient strokes of dense, waxy color—dissolved or not—wax pastels are superb.

The Blue Dory, Karen Coleman, CPSA, 2008, 8" x 11", colored pencil and watercolor pencil on Pastelbord.

To show the rough, well-worn texture of this old boat and its contents, discovered on a trip to Lunenburg, Nova Scotia, Karen Coleman layered fourteen different waxy colored pencil blues onto Pastelbord. To show the water's fluidity and reflected light, she applied layers of watercolor pencil and then blended them with a wet brush. After the surface dried, she added shadows with dry colored pencil.

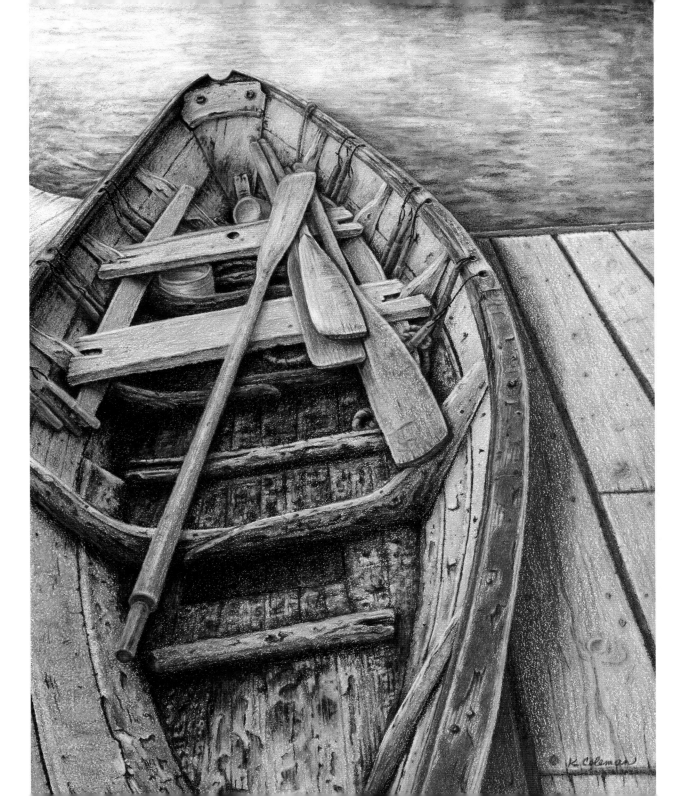

AQUARELLE AS A BASE LAYER FOR TRADITIONAL COLORED PENCIL

Dissolved aquarelle (water-soluble) colored pencil lays down a silky, seamless layer of color, filling in the tooth of the paper or other art surface. Adding layers of non-watercolor waxy pencil over the completely dried watercolor layer creates sharp details and also lends polish and dimension to a piece.

Ultra-sharp and inexpensive Sanford Verithin pencils are often overlooked among the many types of colored pencils. Since they can be sharpened to a needle-like point, they are excellent for fine details and

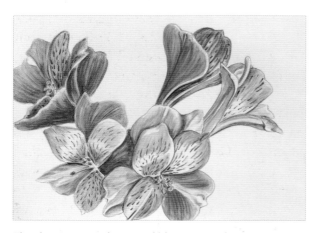

The three watercolor pencil blossoms and stamens on the right have been edged with a violet Verithin pencil; the two flowers on the left have not.

subtle, crisp edges, adding precise finishing touches to a completely dried piece of art. Consider using this pencil, too, for the edges of stamens, pistils, and other fine botanical details, even if the rest of the painting has been done with a water-soluble medium. Verithins truly snap an image into sharp focus.

AQUARELLE AS A COMPLEMENTARY UNDERPAINTING FOR TRADITIONAL COLORED PENCILS

When drawing or painting a complementary under-painting, it is wise to create it with aquarelle pencils rather than watercolor wax pastels. More heavily staining, permanent watercolor pencils such as Caran d'Ache Museums or Derwent Inktense pencils or blocks are a good choice for this first layer. Because wax pastels have great covering power and tend to be opaque, the underlying complement may be more subtle by the final stages.

I started *Tulip Cascade* (page 147) with a pine green complementary underpainting on the tulips before drawing and washing watercolor pencils to show their rosy coral hues. Likewise, I underpainted a wash of magenta and let it dry before applying the water-color pencil greens of the leaves. For gloss and depth, I added traditional non-watercolor pencils over the dried watercolor pencil layer. I gave the tulips extra

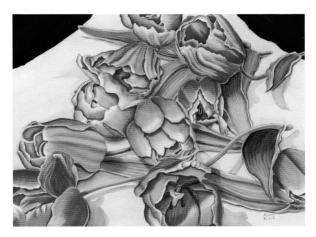

Tulip Cascade, Kristy Ann Kutch, CPSA, 2012, 20" x 15", colored pencil and watercolor pencil on Crescent hot-press watercolor board.

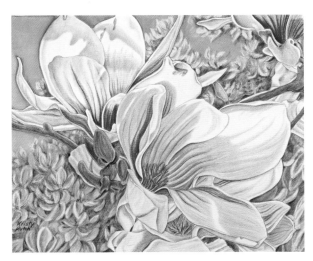

Magnolia Flurry, Kristy Ann Kutch, CPSA, 2009, 15" x 12", colored pencil, watercolor pencil, and water-soluble wax pastel on Fabriano Artistico hot-press paper.

The fuchsia aquarelle accents help advance the white magnolia blooms.

shimmer with strokes of a blending pencil and some repeated layers of waxy, permanent pencil.

Call it what you will, an underpainting or a grisaille creates depth. Noting where the highlights and the shadowy contours appear, think of this as a road map for the colors and values which will eventually be applied. This underpainted approach is helpful with both traditional and water-soluble colored pencils. (Aquarelle wax pastel complements tend to lift easily and mingle, yielding neutrals, however.)

ENHANCING TRADITIONAL COLORED PENCIL WITH WATER-SOLUBLE MEDIA

Often a dry colored pencil painting benefits from a special textural technique or a jolt of extra color emphasis. Whether you want to add roughness and texture for a realistic effect or create a focal point by making a particular area of your painting pop, water-soluble media can often be just the thing to provide that perfect finishing touch.

In *Magnolia Flurry*, I drew and washed the sky first with watercolor wax pastels, moved on to the magnolia blossoms, which were done with traditional waxy colored pencils, and left the white of the paper as the lightest value. The magnolias were lovely but needed the extra punch of strikingly vibrant streaks of interior bold color. I added this emphasis with strokes of fuchsia Inktense water-soluble pencil, drawn and then washed.

Skies Made with Water-soluble Wax Pastel versus Water-soluble Pencil

Although aquarelle wax pastel skies are relatively speedy to paint on Pastelbord, I have discovered that the dense waxiness of the dried layer makes it difficult to draw on since the wax pastel fills in much of the tooth of the art substrate, making it slick. If I want to add clouds or other features in a sky zone done with water-soluble wax pastel, I sometimes apply waxy, dry

ADDING BRIGHT WHITE EMPHASIS

To emphasize the brightest and most powerful whites on clouds, I add strokes with white watercolor pencil such as Stabilo Aquarellable (made for paper, glass, plastic, metal), a white Inktense water-soluble block, or a white water-soluble wax pastel. White NeoArt wax pastel works well for cloud highlights, since it is so creamy and loaded with pigment. I can either stroke the pencil or stick it directly into the damp cloud to make highlights or use a wet brush and paint directly from the pencil or stick. This can be done while the tops of the clouds are still moist, partially dissolving the white pigment into a very strong white. I aim to keep the clouds varied and wispy and try to avoid painting clouds which look like rounded dollops of whipped cream.

colored pencil over the first washed layer with heavy pressure, using a white Stabilo Aquarellable pencil for the very brightest whites. Another strategy I use is to erase in the shape of the forms I plan to draw (such as clouds or birds) with a battery-powered eraser and then draw the features into those spaces on the newly erased surface.

A wash of watercolor pencils to tone Pastelbord creates a colored surface which more readily accepts waxy permanent pencils However, these pencils do not hold the same intensity once they are dissolved. To enrich the background blues of skies painted with a wash of watercolor pencil I recommend reapplying and dissolving a second layer of the same hues before adding cloud banks.

COMBINING ALL THREE COLORED DRAWING MEDIA

I have learned to appreciate the benefits of traditional colored pencils, water-soluble color pencils, and wax pastels, used alone and in combination. While water-soluble pencils lend speed and lovely fluid washes, traditional non-watercolor pencils offer control and precision with no time frame for drying. I appreciate watercolor wax pastels because they are excellent for dense, rich, and speedy color, either alone or used with the two types of colored pencils. Because of their opacity, I have found wax pastels to be ideal for rendering stunningly bright white, foamy waves.

The same two hues of watercolor pencil washed on white Pastelbord result in a lighter, less vivid effect. Next time I would add another layer of dissolved watercolor pencil before drawing in the clouds.

A wash of dark ultramarine and permanent blue wax pastel on white Pastelbord yields very rich sky colors. Erasing back to the white of the board (as on the unfinished right cloud bank) helps when layering brilliant permanent pencil whites in the clouds (as on the left cloud banks.)

Enhancing Landscape Textures with Water-Soluble Media

Hells Canyon, the deepest river gorge in North America, is located along the borders of eastern Washington and Oregon and western Idaho. Carved by the Snake River, it is a prime example of rugged America, majestic and rather desolate. The varied palette of the distant mountains and the bright foreground wildflowers appealed to me. I like Caran d'Ache Luminance pencils for landscapes because they include genuinely earthy hues, especially useful for these forests and volcanic foothills. Although I used mainly traditional pencils for this landscape, the water-soluble pencils and wax pastels added interesting textures and bright emphasis.

1 On light blue Canson Mi-Teintes Touch sanded pastel paper, I sketched the lines of the mountain ridges and the foreground volcanic boulders. I was certain to keep the ridge lines slightly jagged and irregular, representing tree lines along those contours. Starting with the most distant mountain ridges, I used a Luminance white pencil and Caran d'Ache Pablo bluish pale to sketch the snow fields and Luminance light cobalt blue and genuine cobalt blue for the distant furrows and valleys. Keeping the short, choppy strokes in a vertical trend, I imitated the lines of tree growth, even on the distant mountains.

2 I massed foothills in the mid-ground, using Luminance earthy colors for the volcanic soil: burnt ochre 10%, burnt ochre 50%, burnt ochre, Naples ochre, even touches of ultramarine pink and violet gray. Drawing some evergreens, I used gray blue or perylene brown for deep tree depths, with dark sap green, moss green, olive yellow, and spring green (on closer trees) for the green values. The lightest highlights on the trees are buff titanium, which is even lighter than ivory but not quite white. To add distance, I stroked a subtle, cool layer of ultramarine violet on far hillsides.

3 Lemon yellow brightened the sunlit trees on the mountains. On the shadowed ridges I applied light aubergine and lemon yellow. The bleached-out skeletal trees added interest and contrast; I drew them with buff titanium and Cassel earth on the trunks. For the other evergreens, I used dark sap green, moss green, and spring green, with perylene brown as a complementary color for the depths of the boughs. Touches of white, buff titanium, light cobalt blue, and burnt ochre 10% provided sunny highlights on boughs. If the sanded paper became saturated with pigment, I power-erased highlight spots and then touched in the highlight colors.

4 For boulders, I used ultramarine pink, ultramarine violet, brown ochre 10%, russet, burnt sienna, violet brown, burnt ochre, and Cassel brown, adding buff titanium highlights. Spring green, moss green, dark sap green, olive yellow, and perylene brown provided grass colors. I drew and lightly dissolved Indian paintbrush blooms in Museum Aquarelle lemon yellow, orange, and scarlet. Once the flowers dried, I painted highlights directly from a NeoArt Sahara yellow wax pastel. With a wash of NeoArt periwinkle blue and manganese violet stroked onto a spatter screen, I blew through the screen, spattering the foreground wildflowers. I blew a wash of NeoArt white for more wildflowers. Once the violet blossoms were dry, I also blew white highlights on them.

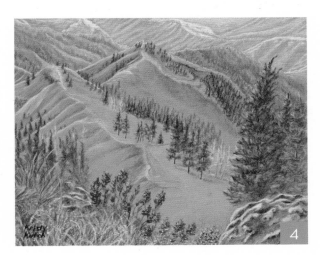

Hells Canyon Hike, Kristy Ann Kutch, CPSA, 2013, 11⁷/₈" x 9¹/₂", colored pencil on Canson Touch sanded paper.

Putting It All Together

I was drawn to this seascape on the Schoodic Peninsula, a lesser-known part of Acadia National Park in Maine. Featuring traditional permanent pencil, watercolor pencil, and dramatic splashes of wax pastel, this scene relies on all three colored drawing media.

1 I decided on a horizon (I tried not to divide my picture in half at the horizon) and, using a ruler, lightly drew the horizon line on Tasman Blue Colourfix Suede paper. With light ultramarine and light phthalo blue Faber-Castell watercolor pencils, I sketched the cloud banks, with white watercolor pencil strokes to indicate the lightest regions of the clouds and light phthalo blue and light ultramarine for the patches of sky and the shadows within the clouds. The cloud banks along the horizon are more distant and are generally smaller, while the clouds higher in the dome of the sky are closer and thus larger and fuller.

2 I swept a dagger striper brush across the sky, parallel to the horizon, wetting white areas first, then blues. I used the narrow side of the brush for cloud banks. The tapered broad side of the brush and its pointed tip rendered swirling cloud banks. I then let the sky dry completely. Keeping a clean edge between the ocean and the sky, I sketched short parallel lines with softly curved dashes of Prussian blue, pine green, and dark indigo, representing the troughs of the distant waves. Proceeding from the horizon to foreground, I gradually drew the lines longer, making wider wave intervals. I lightly drew the angled rock ledges in the foreground.

3 With a dagger striper, starting in the distance, I dissolved the watercolor pencil pigment on the waves, working parallel to the horizon. I repeated dark indigo in the furrows, adding Caran d'Ache permanent blue Museum Aquarelle for waves. After rewashing the ocean, I added dissolved Faber-Castell raw umber as watery rock reflections. Simplifying the rocky ledges, I drew and washed, with a size 2 round, the darkest lines with Faber-Castell dark sepia. On the closest rocky sides, I stroked Faber-Castell olive green yellowish, dark sepia, and caput mortuum violet, washing them with a size 2 round. For the lighter areas of these sides I drew and washed olive green yellowish and dark sepia. Museum permanent blue (light wash) provided watery reflections on the face of the closest vertical rocks.

4 With ivory, raw umber, and burnt sienna I added more aquarelle color to the rocks. On the top, flat part of the rocky slabs, I wetted the colors, light to dark. Imitating rocky vertical ridges, I used vertical strokes of raw umber and burnt sienna, with touches of caput mortuum violet and dark sepia. I used an angle shader, dissolving the strokes with light touches. After the painting was dry, I lightly sketched the form of the wave plume with white watercolor pencil. (This was a subtle guide, not intended as an obvious line drawing.) I power-erased the jagged waves and dusted off the crumbs .

5 I dipped a soft toothbrush into clear water, dabbed it four times, and flicked water droplets where the wave spray should appear. I quickly grated a NeoArt white wax pastel over the clear droplets. (The white pigment only adheres to the wet areas.) Then I took Faber-Castell light cobalt turquoise and grated it over the darker, shadowed parts of the wave, adding dimension. I waited until this layer dried, then I swabbed some white wax pastel wash over a Cheap Joe's spatter screen and blew through it, lending white foamy spray. I finished the sharp rocky ledges with Tuscan red Verithin pencil (the only traditional pencil used in this painting).

Schoodic Peninsula, Maine; Kristy Ann Kutch, CPSA, 2013, 11⁷/₈″ x 9¹/₂″, colored pencil, watercolor pencil, and wax pastel on Colourfix Suede paper.

AFTERWORD

I have pulled out all the stops, dear reader, in sharing my knowledge and enthusiasm for these wonderful little color drawing tools. For more than twenty-five years I have been pushing pencils, enjoying the thrilling satisfaction of using an emerging fine art medium. I hope that you have enjoyed this guide and return to it often!

Hurricane Ridge Profusion; Kristy Ann Kutch, CPSA, 2013, 9" x 12", colored pencil, watercolor pencil, and wax pastel on Colourfix sanded pastel paper.

This mixed media painting recreates a scene from the Olympic Mountains of Washington state. It features the sky, grasses, and trees done with permanent pencils, large, white, fluffy flowers painted with a wax pastels stick, and tiny wildflowers created by blowing watercolor wax pastel and watercolor pencil washed through a splatter screen.

APPENDIX

The world of colored pencils has expanded tremendously in recent years, with new and improved products being launched all the time. Even the classification of what a colored pencil is has changed—and changed again. Colored drawing products are available in an impressive assortment of hues and under various descriptive names. Complicating this world of dazzling color is the fact that color names for the very same hue may differ from one manufacturer to another. This appendix features major colored pencil, watercolor pencil, and wax pastel brands and the color charts corresponding to each manufacturer. Hopefully, these charts will be a convenient reference for the artist working with any brand who wishes to translate and equate color terms.

Bruynzeel Design

Colour and Aquarel pencils

Bruynzeel does not assign color names, only numbers.

#01		#14	
#21		#77	
#19		#51	
#25		#55	
#22		#50	
#16		#68	
#27		#62	
#18		#66	
#23		#60	
#46		#61	
#33		#63	
#31		#42	
#11		#79	
#38		#44	
#36		#43	
#39		#45	
#71		#40	
#70		#88	
#75		#73	
#09		#72	
#57		#81	
#59		#74	
#56		#58	
#91		#10	

Caran d'Ache

Luminance 6901 Permanent Pencils

White, #001
Buff Titanium, #801
Primerose, #242
Naples Ochre, #821
Lemon Yellow, #240
Bismuth Yellow, #810
Golden Bismuth Yellow, #820
Apricot, #041
Orange, #030
Cornelian, #850
Anthraquinoid Pink, #571
Permanent Red, #061
Scarlet, #070
Crimson Alizarin (Hue), #589
Perylene Brown, #585
Crimson Aubergine, # 599
Purplish Red, #350
Ultramarine Pink, #083
Ultramarine Violet, #630
Manganese Violet, #112
Violet Brown, #129
Violet Grey, #093
Light Aubergine, #095
Violet, #120
Prussian Blue, #159
Ice Blue, #185
Phthalocyanine Blue, #162
Genuine Cobalt Blue, #662
Light Cobalt Blue, #661
Middle Cobalt Blue (Hue), #660
Grey Blue, #775
Light Blue, #161
Turquoise Blue, #171
Light Malachite Green, #181
Cobalt Green, #182
Beryl Green, #214
Dark English Green, #729
Malachite Green, #180

Dark Sap Green, #739
Grass Green, #220
Moss Green, #225
Spring Green, #470
Olive Yellow, #015
Green Ochre, #025
Olive Brown, #039
Olive Brown 10%, #732
Olive Brown 50%, #736
Raw Umber, #548
Raw Umber 10%, #842
Raw Umber 50%, #846
Burnt Ochre, #077
Burnt Ochre 10%, #872
Burnt Ochre 50%, #876
Burnt Sienna 10%, #862
Burnt Sienna 50%, #866
Raw Sienna, #036
Yellow Ochre, #034
Brown Ochre, #037
Brown Ochre 10%, #832
Brown Ochre 50%, #836
Russet, #065
Burnt Sienna, #069
Sepia, #407
Sepia 10%, #902
Sepia 50%, # 906
Cassel Earth, #046
French Grey, #808
French Grey 10%, #802
French Grey 30%, #803
Silver Grey, #002
Slate Grey, #495
Payne's Grey, #508
Steel Grey, #004
Payne's Grey 30%, #504
Payne's Grey 60%, #507
Black, #009

Caran d'Ache, continued

Pablo and Supracolor Watercolor Pencils (symbol), Neocolor I Permanent (+ symbol), and Neocolor II Watercolor Wax Pastels (‡ symbol)*

*+‡White, #001
*‡Silver Grey, #002
*+‡Light Grey, #003
*‡Steel Grey, #004
*+‡Grey, #005
*‡Mouse Grey, #006
*‡Dark Grey, #007
*‡Greyish Black, #008
*+‡Black, #009
*+‡Yellow, #010
*‡Pale Yellow, #011
*Olive Yellow, #015
*Khaki Green, #016
*Olive Grey, #018
*‡Olive Black, #019
*‡Golden Yellow, #020
*‡Naples Yellow, #021
*‡Green Ochre, #025
*+‡Orange, #030
*‡Orangish Yellow, #031
*‡Light Ochre, #032
*‡Golden Ochre, #033
*+‡Ochre, #035
*Brown Ochre, #037
*‡Olive Brown, #039
*‡Reddish Orange, #040
*‡Apricot, #041
*Brownish Orange, #043
*‡VanDycke Brown, #045
*Bistre, #047
*+‡Raw Umber, #049
*+‡Flame Red, #050
*+‡Salmon, #051
*Hazel, #053
*‡Cinnamon, #055
*‡Chestnut, #057
*+‡Brown, #059
*+‡Vermillion, #060
*‡Venetian Red, #062
*‡English Red, #063

*+‡Russet, #065
*Mahogany, #067
*+‡Burnt Sienna, #069
*+‡Scarlet, #070
*‡Salmon Pink, #071
*‡Indian Red, #075
*+‡Carmine, #080
*+Pink, #081
*‡Rose Pink, #082
*‡Bordeaux Red, #085
*Dark Carmine, #089
*+‡Purple, #090
*Light Purple, #091
*Aubergine, #099
*‡Purple Violet, #100
*+‡Lilac, #110
*‡Mauve, #111
*+‡Violet, #120
*Royal Blue, #130
*+‡Periwinkle Blue, #131
*Indigo Blue, #139
*+‡Ultramarine Blue, #140
*‡Sky Blue, #141
*Bluish Grey, #145
*‡Night Blue, #149
*‡Sapphire Blue, #150
*Pastel Blue, #151
*Blue Jeans, #155
*+‡Prussian Blue, #159
*+‡Cobalt Blue, #160
*+‡Light Blue, #161
*Marine Blue, #169
*‡Azurite Blue, #170
*+‡Turquoise Blue, #171
*+‡Malachite Green, #180
*Malachite Light Green, #181
*‡Greenish Blue, #190
*‡Turquoise Green, #191
*Opaline Green, #195
*‡Bluish Green, #200

*‡Veronese Green, #201
*+‡Emerald Green, #210
*‡Jade Green, #211
*Greyish Green, #215
*+‡Grass Green, #220
*‡Light Green, #221
*‡Moss Green, #225
*‡Dark Green, #229
*+‡Yellow Green, #230
*‡Lime Green, #231
*Spruce Green, #239
*+‡Lemon Yellow, #240
*‡Light Lemon Yellow, #241
*+‡Light Olive Green, #245
*+‡Olive Green, #249
*‡Canary Yellow, #250
*‡Blue, #260
*‡Raspberry Red, #270
*‡Ruby Red, #280
*‡Empire Green, #290
*‡Fast Orange, #300
*‡Purplish Red, #350
*‡Gentian Blue, #370
*Bluish Pale, #371
*‡Ash Grey, #401
*‡Light Beige, #402
*‡Beige, #403
*Brownish Beige, #404
*‡Cocoa, #405
*‡Sepia, #407
*‡Charcoal Grey, #409
*Peacock Green, #460
*‡Spring Green, #470
*Cream, #491
*Granite Rose, #493
*Slate Grey, #495
*Ivory Black, #496
*+‡Bronze, #497
*+‡Silver, #498
*+‡Gold, #499

Caran d'Ache, continued

Neocolor I (+ symbol) and Neocolor II Wax Pastels (symbol)*

+*Crimson Alizarin Hue, #589
*Dk. English Grn., #729
+*Dk. Gold Metallic, #899
+*Dk. Ultramarine, #640
*Flesh, #042
*Gold Cadmium Yellow, #530
*Ice Blue, #185
+*Lt. Cadmium Red Hue , #560
+*Lt. Cobalt Blue Hue, #661
*Manganese Violet, #112
*Middle Cobalt Blue Hue, #660
+*Payne's Gray, #508
+*Phthalo Blue Metallic, #162
+*Phthalo Green Metallic, #710
+*Pink Metallic, #081

*Raw Sienna, #036
*Saffron, #052
+*Sahara Yellow, #521
+*Ash Grey Metallic, #401
+*Scarlet Metallic, #070
+*Toledo Brown, #028
*Ultramarine Pink, #083
+*Violet Metallic, #120
*Bismuth Green, #193
*Chinese Green, #730
*Bright Green, #720
*Burnt Umber, #549
*Cobalt Grn. Hue, #182
*Cobalt Violet Hue, #620
*Chromium Oxide Grn., #212

Caran d'Ache, continued

Caran d'Ache NeoArt Aquarelle Semi-Opaque Wax Pastels

This is a different product than the Neocolor line, although it is also a watersoluble wax pastel, in the high-end price range.

White, #001
Light Grey, #003
Grey, #005
Black, #009
Yellow, #010
Golden Yellow, #020
Green Ochre, #025
Toledo Brown, #028
Ochre, #035
Raw Siena, #036
Olive Brown, #039
Reddish Orange, #040
Flesh, #042
Salmon, #051
Saffron, #052
Vermilion, #060
English Red, #063
Russet, #065
Burnt Siena, #069
Scarlet, #070
Carmine, #080
Ultramarine Pink, #083
Dark Carmine, #089
Purple Violet, #100
Manganese Violet, #112
Periwinkle Blue, #131
Sky Blue, #141
Night Blue, #149
Prussian Blue, #159
Light Blue, #161

Phtalocyanine Blue, #162
Azurite Blue, #170
Turquoise Blue, #171
Malachite Green, #180
Ice Blue, #185
Emerald Green, #210
Grass Green, #220
Moss Green, #225
Yellow Green, #230
Lemon Yellow, #240
Light Olive, #245
Olive, #249
Blue, #260
Purplish Red, #350
Beige, #403
Cocoa, #405
Spring Green, #470
Silver, #498
Gold, #499
Payne's Grey, #508
Sahara Yellow, #521
Golden Cadmium Yellow, #530
Genuine Umber, #548
Burnt Umber, #549
Light Cadmium Red, #560
Cobalt Violet, #620
Dark Ultramarine, #640
Middle Cobalt Blue, #660
Permanent Blue, #670
Dark English Green, #729

Caran d'Ache, continued

Museum Aquarelle Pencils

These are the newest watercolor pencils from Caran d'Ache. A very staining, intensely pigmented, high-end product.

White, #001
Black, #009
Olive Yellow, #015
Orange, #030
Yellow Ochre, #034
Raw Sienna, #036
Olive Brown, #039
Raw Umber, #049
Brown, #059
Vermilion, #060
Russet, #065
Scarlet, #070
Burnt Ochre, #077
Periwinkle Blue, #131
Night Blue, #149
Prussian Blue, #159
Light Blue, #161
Turquoise Blue, #171
Cobalt Green, #182
Chromium Oxide Green, #212
Beryl Green, #214
Dark Green, #229

Lemon Yellow, #240
Primerose, #242
Light Olive, #245
Purplish Red, #350
Spring Green, #470
Ivory Black, #496
Payne's Grey 60%, #507
Payne's Grey, #508
Gold Cadmium Yellow, #530
Light Cadmium Red, #560
Crimson Aubergine, #599
Ultramarine Violet, #630
Dark Ultramarine, #640
Middle Cobalt Blue, #660
Light Cobalt Blue, #661
Cerulean Blue, #662
Permanent Blue, #670
Phthalocyanine Green, #710
Bright Green, #720
Dark Sap Green, #739
French Grey, #808
Cornelian, #850

Cretacolor

Aquamonolith watercolor pencil rods (no extra symbol), Marino watersoluble pencils (symbol), and Karmina permanent (non-watercolor) pencils (+ symbol)*

*+Permanent White, #101	Bremen Blue, #163
Sunproof Yellow Citron, #103	Smyrna Blue, #164
Flash Yellow, #104	*+Turquoise Dark, #176
*+Naples Yellow, #105	*+Emerald, #177
Straw Yellow, #106	*+Leaf Green, #178
*+Cadmium Citron, #107	Fir Green, #179
*+Chromium Yellow, #108	Light Green, #180
Permanent Dark Yellow, #109	*+Moss Green Light, #181
*+Orange, #111	*+Moss Green Dark, #182
Vermillion Light, #112	French Green, #183
Vermillion Dark, #114	*+Grass Green, #184
*+Permanent Red Light, #113	Lime Green, #185
*+Permanent Red Dark, #115	Pea Green, #187
*+Carmine Extra Fine, #116	Olive Green Light, #188
*+Madder Carmine, #117	Green Earth Light, #189
Mars Violet Light, #125	Green Earth Dark, #190
*+Magenta, #128	*+Olive Green Dark, #191
Tan Dark, #130	Umber Green Light, #192
*+Tan Light, #131	*+Ivory, #201
English Rose, #132	*+Ochre Light, #202
*+Cyclamen, #134	*+Ochre Dark, #203
*+Old Rose Light, #135	Sienna Natural, #204
Old Rose Dark, #136	*+English Red, #209
*+Violet, #138	Red Brown, #211
Mars Violet Dark, #140	Indian Red, #212
Pastel Blue, #150	Pompeian Red, #213
Glacier Blue, #151	*+Chestnut Brown, #215
*+Delft Blue, #153	Olive Brown, #216
Cobalt Blue, #154	Sepia Light, #218
*+Ultramarine, #155	Van Dycke Brown, #220
*+Blue Violet, #156	*+Umber, #221
Mountain Blue, #157	*+Light Grey, #232
*+Light Blue, #158	*+Dark Grey, #235
Medium Blue, #159	Blue Grey, #237
*+Prussian Blue, #161	*+Ivory Black, #250
*+Indigo, #162	Graphite Aquarell, #260

Derwent

Artists (no extra symbol), Watercolour (symbol), and Studio Pencils (+ symbol)*

Lime
*+Zinc Yellow, #01
*+Lemon Cadmium, #02
*+Gold, #03
*+Primrose Yellow, #04
Champagne
*+Straw Yellow, #05
Buttercup Yellow
*+Deep Cadmium, #06
*+Naples Yellow, #07
*+Middle Chrome, #08
*+Deep Chrome, #09
*+Orange Chrome, #10
*+Spectrum Orange, #11
*+Scarlet Lake, #12
*+Pale Vermilion, #13
*+Deep Vermilion, #14
Bright Red
*+Geranium Lake, #15
*+Flesh Pink, #16
Light Sienna
Salmon
Ash Rose
*+Pink Madder Lake, #17
*+Rose Pink, #18
Rioja
*+Madder Carmine, #19
Claret
*+Crimson Lake, #20
*+Rose Madder Lake, #21
Plum
Grape
*+Magenta, #22
Heather
Soft Violet
*+Imperial Purple, #23
*+Red Violet Lake, #24
Slate Violet
*+Dark Violet, #25
*+Light Violet, #26

*+Blue Violet Lake, #27
*+Delft Blue, #28
Royal Blue
Mid-Ultramarine
Teal Blue
Pale Ultramarine
*+Ultramarine, #29
*+Smalt Blue, #30
*+Cobalt Blue, #31
*+Spectrum Blue, #32
*+Light Blue, #33
*+Sky Blue, #34
*+Prussian Blue, #35
*+Indigo, #36
Ash Blue
Phthalo Blue
*+Oriental Blue, #37
Midnight Blue
*+Kingfisher Blue, #38
*+Turquoise Blue, #39
*+Turquoise Green, #40
*+Jade Green, #41
Cobalt Green
Fir Green
Spruce Green
Distant Green
Phthalo Green
*+Juniper Green, #42
*+Bottle Green, #43
*+Water Green, #44
*+Mineral Green, #45
*+Emerald Green, #46
*+Grass Green, #47
*+May Green, #48
*+Sap Green, #49
*+Cedar Green, #50
Green Grey
*+Olive Green, #51
Moss Green
Light Moss

Chartreuse
Green Earth
Parchment
Olive Earth
*+Bronze, #52
*+Sepia, #53
Felt Grey
*+Burnt Umber, #54
*+Vandyke Brown, #55
*+Raw Umber, #56
*+Brown Ochre, #57
Light Ochre
Yellow Ochre
*+Raw Sienna, #58
*+Golden Brown, #59
*+Burnt Yellow Ochre, #60
*+Copper Beech, #61
*+Burnt Sienna, #62
*+Venetian Red, #63
*+Terracotta, #64
Sunset Gold
Autumn Leaf
Rust
Light Rust
Mahogany
Burnt Rose
Mars Violet
Taupe
Bistre
*+Burnt Carmine, #65
*+Chocolate, #66
Mars Black
*+Ivory Black, #67
*+Blue Grey, #68
*+Gunmetal, #69
Storm Grey
*+French Grey, #70
*+Silver Grey, #71
Felt Mist
*+Chinese White, #72

Derwent, continued

Coloursoft Coloured Pencils

These are also non-watercolor pencils, but they're softer and creamier than Studio Pencils.

Cream, #C010
Acid Yellow, #C020
Lemon Yellow, #C030
Deep Cadmium, #C040
Yellow Ochre, #C050
Pale Orange, #C060
Orange, #C070
Bright Orange, #C080
Blood Orange, #C090
Rose, #C100
Scarlet, #C110
Red, #C120
Deep Red, #C130
Deep Fuchsia, #C140
Cranberry, #C150
Loganberry, #C160
Soft Pink, #C170
Blush Pink, #C180
Pink, #C190
Bright Pink, #C200
Pink Lavender, #C210
Grey Lavender, #C220
Pale Lavender, #C230
Bright Purple, #C240

Purple, #C250
Bright Lilac, #C260
Royal Purple, #C270
Blackberry, #C280
Ultramarine, #C290
Indigo, #C300
Prussian Blue, #C310
Electric Blue, #C320
Blue, #C330
Baby Blue, #C340
Iced Blue, #C350
Cloud Blue, #C360
Pale Blue, #C370
Sea Green, #C380
Grey Green, #C390
Mid Green, #C400
Dark Green, #C410
Green, #C420
Pea Green, #C430
Light Green, #C440
Yellow Green, #C450
Lime Green, #C460
Mint, #C470
Lincoln Green, #C480

Pale Mint, #C490
Lichen Green, #C500
Brown, #C510
Dark Brown, #C520
Pale Brown, #C530
Pimento, #C540
Ginger, #C550
Peach, #C560
Pale Peach, #C570
Light Sand, #C580
Ochre, #C590
Mid Brown, #C600
Dark Terracotta, #C610
Mid Terracotta, #C620
Brown Earth, #C630
Brown Black, #C640
Black, #C650
Persian Grey, #C660
Dove Grey, #C670
Petrel Grey, #C680
Steel Grey, #C690
Mid Grey, #C700
White Grey, #C710
White, #C720

Derwent Drawing Pencils

These are very soft drawing pencils with a limited, muted palette from nature.

Light Sienna, #1610
Solway Blue, #3615
Ink Blue, #3720
Smoke Blue, #3810
Pale Cedar, #4125
Green Shadow, #4135
Crag Green, #5090
Olive Earth, #5160

Warm Earth, #5550
Brown Ochre, #5700
Wheat, #5715
Yellow Ochre, #5720
Sepia (Red), #6110
Mars Orange, #6210
Sanguine, #6220
Venetian Red, #6300

Terracotta, #6400
Mars Violet, #6470
Ruby Earth, #6510
Chocolate, #6600
Ivory Black, #6700
Warm Grey, #7010
Cool Grey, #7120
Chinese White, #7200

Derwent, continued

Inktense Pencils and Inktense Blocks

Blocks are available in all of the same hues as Inktense pencils, both are watersoluble.

Sherbet Lemon, #0100
Sun Yellow, #0200
Cadmium Yellow, #0210
Sicilian Yellow, #0220
Golden Yellow, #0230
Sienna Gold, #0240
Cadmium Orange, #0250
Burnt Orange, #0260
Tangerine, #0300
Mid-Vermillion, #0310
Scarlet Pink, #0320
Poppy Red, #0400
Hot Red, #0410
Chili Red, #0500
Cherry, #0510
Carmine Pink, #0520
Crimson, #0530
Shiraz, #0600
Red Violet, #0610
Fuchsia, #0700
Deep Rose, #0710
Thistle, #0720
Dusky Purple, #0730
Mauve, #0740

Dark Purple, #0750
Deep Violet, #0760
Violet, #0800
Lagoon, #0810
Peacock Blue, #0820
Navy Blue, #0830
Iron Blue, #0840
Deep Blue, #0850
Iris Blue, #0900
Bright Blue, #1000
Deep Indigo, #1100
Sea Blue, #1200
Dark Aquamarine, #1210
Turquoise, #1215
Green Aquamarine, #1220
Mallard Green, #1230
Teal Green, #1300
Iron Green, #1310
Ionian Green, #1320
Vivid Green, #1330
Apple Green, #1400
Field Green, #1500
Beech Green, #1510
Hooker's Green, #1520

Felt Green, #1530
Light Olive, #1540
Spring Green, #1550
Fern, #1560
Leaf Green, #1600
Mustard, #1700
Amber, #1710
Tan, #1720
Oak, #1730
Saddle Brown, #1740
Baked Earth, #1800
Willow, #1900
Red Oxide, #1910
Madder Brown, #1920
Dark Chocolate, #1930
Bark, #2000
Sepia Ink, #2010
Indian Ink, #2020
Chinese Ink, #2030
Charcoal Grey, #2100
Payne's Grey, #2110
Neutral Grey, #2120
Ink Black, #2200
Antique White, #2300

Derwent Graphitint Pencils

These are watersoluble watercolor graphite pencils with color added.

Port, #01
Juniper, #02
Aubergine, #03
Dark Indigo, #04
Shadow, #05
Steel Blue, #06
Ocean Blue, 07
Slate Green, #04

Green Grey, #09
Meadow, #10
Ivy, #11
Sage, #12
Chestnut, #13
Russet, #14
Cool Brown, #15
Cocoa, #16

Autumn Brown, #17
Storm, #18
Warm Grey, #19
Midnight Black, #20
Mountain Grey, #21
Cloud Grey, #22
Cool Grey, #23
White, #24

Derwent, continued

Artbar Watersoluble Wax Pastels

Process Yellow, #A01

Primary Yellow, #A02

Marigold, #A03

Tertiary Orange, #A04

Primary Red, #A05

Strawberry, #A06

Carnation, #A07

Process Magenta, #A08

Tertiary Purple, #A09

Iris, #A10

Primary Blue, #A11

Ultra Blue, #A12

Process Cyan #A13

Topaz, #A14

Turquoise, #A15

Tertiary Green, #A16

Bright Green, #A17

Kiwi, #A18

Wheat, #A19

Pale Lemon, #A20

Sweetcorn, #A21

Mango, #A22

Blush, #A23

Vivid Pink, #A24

Violet Oxide, #A25

Soft Lavender, #A26

Lilac, #A27

Pale Cobalt, #A28

Baby Blue, #A29

Blue Lace, #A30

Duck Egg Blue, #A31

Spearmint, #A32

Gooseberry, #A33

Popcorn, #A34

Pink Oxide, #A35

Beige, #A36

Honeycomb, #A37

Ochre, #A38

Paprika, #A39

Spice, #A40

Praline, #A41

Violet Earth, #A42

Amethyst, #A43

Pacific Blue, #A44

Cool Grey, #A45

Mid Grey, #A46

Deep Aqua, #A47

Mediterranean, #A48

Green Earth, #A49

Cactus, #A50

Prairie, #A51

Raw Umber, #A52

Cocoa, #A53

Warm Grey, #A54

Natural Brown, #A55

Burnt Umber, #A56

Nutmeg, #A57

Alizarin, #A58

Dark Indigo, #A59

Midnight, #A60

Prussian, #A61

Dark Turquoise, #A62

Scots Pine, #A63

Dark Forest, #A64

Racing Green, #A65

Payne's Grey, #A66

Black, #A67

Blue Grey, #A68

Red Grey, #A69

Yellow Grey, #A70

Mixing Bar, #A71

Opaque White, #A72

Faber-Castell

Polychromos and Albrecht Dürer Watercolor Pencils

Color palette is the same for both watercolor and nonwatercolor versions.

White, #101
Ivory, #103
Cream, #102
Light Yellow Glaze, #104
Cadmium Yellow Lemon, #205
Light Cadmium Yellow, #105
Light Chrome Yellow, #106
Cadmium Yellow, #107
Dark Cadmium Yellow, #108
Dark Chrome Yellow, #109
Cadmium Orange, #111
Orange Glaze, #113
Dark Cadmium Orange, #115
Light Cadmium Red, #117
Scarlet Red, #118
Pale Geranium Lake, #121
Deep Scarlet Red, #219
Permanent Carmine, #126
Deep Red, #223
Middle Cadmium Red, #217
Dark Red, #225
Madder, #142
Alizarin Crimson, #226
Pink Carmine, #127
Rose Carmine, #124
Light Purple Pink, #128
Fuchsia, #123
Magenta, #133
Light Magenta, #119
Pink Madder Lake, #129
Middle Purple Pink, #125
Crimson, #134
Manganese Violet, #160
Violet, #138
Purple Violet, #136
Blue Violet, #137
Mauve, #249
Delft Blue, #141
Dark Indigo, #157
Indianthrene Blue, #247

Helioblue Reddish, #151
Cobalt Blue, #143
Ultramarine, #120
Light Ultramarine, #140
Smalt Blue, #146
Cobalt Blue Greenish, #144
Phthalo Blue, #110
Middle Phthalo Blue, #152
Light Phthalo Blue, #145
Bluish Turquoise, #149
Prussian Blue, #246
Helio Turquoise, #155
Cobalt Turquoise, #153
Light Cobalt Turquoise, #154
Cobalt Green, #156
Deep Cobalt Green, #158
Hooker's Green, #159
Dark Phthalo Green, #264
Chrome Oxide Green Fiery, #276
Phthalo Green, #161
Emerald Green, #163
Light Phthalo Green, #162
Light Green, #171
Grass Green, #166
Leaf Green, #112
Permanent Green, #266
Permanent Green Olive, #167
Pine Green, #267
Chrome Oxide Green, #278
Juniper Green, #165
Olive Green Yellowish, #173
Green Gold, #268
May Green, #170
Earth Green Yellowish, #168
Chrome Green Opaque, #174
Earth Green, #172
Caput Mortuum, #169
Caput Mortuum Violet, #263
Burnt Carmine, #193
Red-Violet, #194

Light Red-Violet, #135
Dark Flesh, #130
Medium Flesh, #131
Light Flesh, #132
Cinnamon, #189
Pompeian Red, #191
Indian Red, #192
Venetian Red, #190
Sanguine, #188
Burnt Ochre, #187
Terracotta, #186
Light Yellow Ochre, #183
Naples Yellow, #185
Dark Naples Yellow, #184
Brown Ochre, #182
Raw Umber, #180
Bistre, #179
Van Dyck Brown, #176
Nougat, #178
Burnt Umber, #280
Burnt Siena, #283
Walnut Brown, #177
Dark Sepia, #175
Warm Grey VI, #275
Warm Grey V, #274
Warm Grey IV, #273
Warm Grey III, #272
Warm Grey II, #271
Warm Grey I, #270
Cold Grey I, #230
Cold Grey II, #231
Cold Grey III, #232
Cold Grey IV, #233
Cold Grey V, #234
Cold Grey VI, #235
Payne's Grey, #181
Black, #199
Silver, #251
Gold, #250
Copper, #252

Koh-I-Noor

Hardtmuth Polycolor pencils

White, #1
Light Yellow, #2
Yellow, #3
Dark Yellow, #4
Orange, #5
Vermillion, #6
Carmine, #7
Bordeaux Red, #8
Beige, #9
Pink, #10
Light Violet, #11
Red Violet, #12
Violet, #13
Blue Violet, #14
Ice Blue, #15
Sky Blue, #16
Cobalt, #17
Light Blue, #18

Dark Blue, #19
Prussian Blue, #20
Blue Green, #21
Bice Green, #22
Dark Olive Green, #27
Pea Green, #24
Grass Green, #25
May Green, #23
Dark Green, #26
Gold Ochre, #28
Dark Ochre, #29
Indian Red, #30
Light Brown, #31
Brown, #32
Dark Brown, #33
Bluish Grey, #34
Grey, #35
Black, #36

Lyra

Polycolor (no extra symbol), Aquarelle (symbol), Colorstripe Colored Pencils (+ symbol), and Aquacolor Wax Pastels (‡ symbol)*

Polycolor pencils are non-watercolor pencils, Colorstripes are colored pencils for wide-stroke applications, Aquarelles are watercolor pencils and Aquacolors are watercolor wax pastels which look like watercolor crayons. Note that Gold, #250, Chartreuse, #304, and Hot Pink, #328, are available only as Colorstripe pencils.

*+‡White, #01
*‡Zinc Yellow, #04
*Light Chrome, #06
*‡Canary Yellow, #08
*+‡Light Orange, #13
*‡Vermilion, #17
*‡Pale Geranium Lake, #21
*‡Dark Carmine, #26
*‡Rose Madder Lake, #28
*‡Dark Flesh, #30
*+‡Light Flesh, #32
*‡Magenta, #34
*+Dark Violet, #36
*Violet, #38
*Delft Blue, #41
*‡Light Cobalt, #44
*+‡Light Blue, #47
*Oriental Blue, #49
*+‡Prussian Blue, #51
*+‡Aquamarine, #54
*Sea Green, #58
*‡Viridian, #61
*Emerald Green, #63
*+‡Sap Green, #67
*‡Apple Green, #70
*Grey Green, #72
*‡Cedar Green, #74
*+‡Van Dyck Brown, #76
*‡Brown Ochre, #82
*‡Ochre, #84
*‡Burnt Ochre, #87
*‡Venetian Red, #90

*‡Indian Red, #92
*Purple, #94
*‡Silver Grey, #96; #251 as Colorstripe
*Dark Grey, #98
+Gold, #250
+Chartreuse, #304
*Cream, #02
*‡Lemon Cadmium, #05
*+‡Lemon, #07
*‡Orange Yellow, #09
*‡Dark Orange, #15
*+Scarlet Lake, #18
*‡Rose Carmine, #24
*‡Light Carmine, #27
*+Pink Madder Lake, #29
*Medium Flesh, #31
*Wine Red, #33
*Red Violet, #35
*‡Blue Violet, #37
*+Light Violet, #39
*‡Deep Cobalt, #43
*‡Sky Blue, #46
*‡True Blue, #48
*Paris Blue, #50
*‡Peacock Blue, #53
*‡Night Green, #55
*Hooker's Green, #59
*True Green, #62
*Juniper Green, #65
*‡Moss Green, #68
*‡Light Green, #71
*‡Olive Green, #73

*‡Dark Sepia, #75
*‡Raw Umber, #80
*‡Gold Ochre, #83
*Light Ochre, #85
*Cinnamon, #89
*‡Pompeian Red, #91
*Burnt Carmine, #93
*‡Light Grey, #95
*‡Medium Grey, #97
*+‡Black, #99
+Hot Pink, #328

Sanford

Prismacolor Thick-Core Pencils (no extra symbol), Watercolor Pencils (symbol), and Art Stix (+ symbol)*

Sand, #940
Neon Yellow, #1035
*Cream, #914
*Sunburst Yellow, #917
Yellow Ochre, #942
Lemon Yellow, #915
Beige, #997
*+Canary Yellow, #916
Jasmine, #1012
*+Goldenrod, #1034
Deco Yellow, #1011
Yellow Chartreuse, #1004
Metallic Gold, #950
Bronze, #1028
Sepia, #948
*+Sienna Brown, #945
Burnt Ochre, #943
*+Dark Brown, #946
*Dark Umber, #947
Light Umber, #941
*Terra Cotta, #944
*+Black, #935
*+White, #938
Muted Turquoise, #1088
Electric Blue, #1040
Blue Violet Lake, #1079
*+True Blue, #903
Aquamarine, #905
*+Indigo Blue, #901
*Ultramarine, #902
*Copenhagen Blue, #906
*Non-Photo Blue, #919
*+Violet Blue, #933
Mediterranean Blue, #1022
Chocolate, #1082
Cloud Blue, #1023
Periwinkle, #1025
*Peacock Blue, #1027

Chartreuse, #989
*+True Green, #910
Peacock Green, #907
*+Grass Green, #909
+Apple Green, #912
Prussian Green, #109
Light Green, #920
Marine Green, #988
Limepeel, #1005
Celadon Green, #1020
*Olive Green, #911
*Spring Green, #913
Jade Green, #1021
*Parrot Green, #1006
*+Dark Green, #908
*+Orange, #918
Pale Vermillion, #921
Salmon Pink, #1001
+Spanish Orange, #1003
+Peach, #939
Yellowed Orange, #1002
*Light Peach, #927
Mineral Orange, #1033
Pumpkin Orange, #1032
Espresso, #1099
Neon Orange, #1036
Deco Peach, #1013
Rosy Beige, #1019
Dark Purple, #931
Greyed Lavender, #1026
*Lilac, #956
Black Grape, #996
+Parma Violet, #1008
*+Violet, #932
Lavender, #934
Imperial Violet, #1007
Black Cherry, #1078
Dahlia Purple, #1009

Sanford, continued

Prismacolor Thick-Core Pencils (no extra symbol), Watercolor Pencils (symbol), and Art Stix (+ symbol)*

Blue Slate, #1024
Light Aqua, #992
Lt.Cerulean #904,+Lt. Blue Stix
Ginger Root, #1084
Cadmium Orange, #118
Nectar, #1092
Beige Sienna, #1080
Dioxazine Purple Hue, #132
China Blue, #1100
Cerulean Blue, #103
Blue Lake, #1102
Pale Sage, #1089
Sap Green Light, #120
+Tuscan Red, #937
Kelp Green, #1090
Eggshell, #140
Artichoke, #1098
Permanent Red, #122
Peach Beige, #1085
Chestnut, #1081
Indanthrone Blue, #208
Denim Blue, #1101
Powder Blue, #1087
Cobalt Turquoise, #105
Moss Green, #1097
Kelly Green, #1096
*Cool Grey 50%, #1063
Cool Grey 70%, #1065
Cool Grey 90%, #1067
Pomegranate, #195
Seashell Pink, #1093
Black Raspberry, #1095
Cobalt Blue Hue, #133
Sky Blue Light, #1086
Caribbean Sea, #1103
Grey Green Light, #289
Green Ochre, #1091
Colorless (Blender), #1077

Scarlet Lake, #923
*Blush Pink, #928
*+Pink, #929
*+Crimson Red, #924
+Scarlet, #922, Art Stix only
Hot Pink, #993
*+Mulberry, #995
Pink Rose, #1018
*Carmine Red, #926
Process Red, #994
Neon Pink, #1038
Putty Beige, #1083
Deco Pink, #1014
Clay Rose, #1017
Magenta, #930
Crimson Lake, #925
Raspberry, #1030
*Poppy Red, #922
Mahogany Red, #1029
Henna, #1031
Sandbar Brown, #1094
Slate Grey, #936
Metallic Silver, #949
Warm Grey 10%, #1050
Warm Grey 20%, #1051
Warm Grey 30%, #1052
Warm Grey 50%, #1054
Warm Grey 70%, #1056
Warm Grey 90%, #1058
French Grey 10%, #1068
*French Grey 20%, #1069
French Grey 30%, #1070
French Grey 50%, #1072
French Grey 70%, #1074
French Grey 90%, #1076
Cool Grey 10%, #1059
Cool Grey 20%, #1060
Cool Grey 30%, #1061

Stabilo

Woody Watersoluble Wax Pastels

These look like jumbo crayons.

White, #100
Yellow, #205
Orange, #220
Carmine, #310
Rose, #334
Light Flesh Tint, #355
Lilac, #370
Violet, #385
Ultramarine, #405

Dark Blue, #425
Light Blue, #450
Ice Green, #470
Emerald Green, #533
Light Green, #570
Brown, #630
Black, #750
Silver, #805
Gold, #810
Aquarellable White, #8052

Tombow

Irojiten Color Dictionary Pencils: Deep and Deep II (D), Dull (Dl), Fluorescence (F), Light Grayish Tone (Lg), Pale and Pale II (P), Very Pale (Vp), Vivid (V)

"Irojiten" means "color dictionary" in Japanese.

Orchid Pink, #P-1	Rose Pink, #P-11	Plastic Pink, #F-1
Coral Pink, #P-2	Apricot, #P-12	Surprise Red, #F-2
Shell Pink, #P-3	Gamboge, #P-13	Equatorial Orange, #F-3
Narcissus, #P-4	Straw Yellow, #P-14	Sunset Orange, #F-4
Lettuce Green, #P-5	Spring Green, #P-15	Dazzling Sun, #F-5
Ice Green, #P-6	Mint Green, #P-16	Firefly Yellow, #F-6
Aqua, #P-7	Turquoise, #P-17	Lightning Yellow, #F-7
Forget Me Not Blue, #P-8	Celeste Blue, #P-18	Neon Green, #F-8
Lilac, #P-9	Hyacinth Blue, #P-19	Flash Green, #F-9
Pigeon Gray, #P-10	Crocus, #P-20	Vigorous Green, #F-10
Cherry Red, #V-1	Plum, #D-11	Cameo Pink, #Vp-1
Tangerine Orange, #V-2	Maroon, #D-12	Almond Blossom, #Vp-2
Dandelion, #V-3	Terra Cotta, #D-13	Ecru, #Vp-3
Chartreuse Green, #V-4	Bamboo, #D-14	Eggshell, #Vp-4
Parrot Green, #V-5	Mustard, #D-15	Asparagus, #Vp-5
Peacock Blue, #V-6	Moss Green, #D-16	Opal Green, #Vp-6
King Fisher, #V-7	Cactus Green, #D-17	Cascade, #Vp-7
Lapis Lazuli, #V-8	Spruce, #D-18	Horizon Blue, #Vp-8
Iris Violet, #V-9	Teal Blue, #D-19	Lupine, #Vp-9
Ivory Black, #V-10	Indigo, #D-20	Verbena, #Vp-10
Crimson, #D-1	Fawn, #Lg-1	Cedarwood, #Dl-1
Chestnut Brown, #D-2	Cork, #Lg-2	Cinnamon, #Dl-2
Autumn Leaf, #D-3	Sallow, #Lg-3	Oil Yellow, #Dl-3
Maple Sugar, #D-4	Wax Yellow, #Lg-4	Sage Green, #Dl-4
Olive Yellow, #D-5	Willow, #Lg-5	Verdigris, #Dl-5
Elm Green, #D-6	Mist Green, #Lg-6	Hummingbird, #Dl-6
Forest Green, #D-7	Quartz Green, #Lg-7	Jay Blue, #Dl-7
Midnight Blue, #D-8	Porcelain Blue, #Lg-8	Hydrangea Blue, #Dl-8
Mulberry, #D-9	Campanula Blue, #Lg-9	Heather, #Dl-9
Taupe, #D-10	Sea Fog, #Lg-10	Tyrian Purple, #Dl-10

BIBLIOGRAPHY

Baird, Cecile. *Painting Light with Colored Pencil*, Cincinnati: North Light Books, 2008.

Borgeson, Bet. *The Colored Pencil* (rev. ed.), New York: Watson-Guptill Publications, 1995.

_____. *Colored Pencil Fast Techniques*, New York: Watson-Guptill Publications, 1988.

_____. *Colored Pencil for the Serious Beginner*, New York: Watson-Guptill Publications, 1998.

Edwards, Betty. *Color*, New York: Jeremy P. Tarcher/Putnam, 2004.

_____. *The New Drawing on the Right Side of the Brain*, New York: Jeremy P. Tarcher/Putnam, 1999.

Gildow, Janie. "Capturing the Perfect Color." *The Artist's Magazine*, November 1996, 58–62.

Jasper, Caroline. *Power Color*, New York: Watson-Guptill Publications, 2005.

Kutch, Kristy. *Drawing and Painting with Colored Pencil*, New York: Watson-Guptill Publications, 2005.

Nickelson, Alyona. *Colored Pencil Painting Bible*, New York: Watson-Guptill Publications, 2009.

Shorr, Harriet. *The Artist's Eye*, New York: Watson-Guptill Publications, 1990.

Sidaway, Ian. *Color Mixing Bible*, New York: Watson-Guptill Publications, 2002.

INDEX